Christopher Grey's

STUDIO LIGHTING
TECHNIQUES FOR PHOTOGRAPHY

AMHERST MEDIA, INC. ◻ BUFFALO, NY

ABOUT THE AUTHOR

Photo by Joey Tichenor.

Christopher Grey is an internationally acclaimed and noted world-class photographer, instructor, and author based in Minneapolis, MN. His still photography has won many national and international awards for excellence for clients such as the Dairy Association (Got Milk?), as have several of the television commercials he's directed, such as the Addy he won for Lexus of Clearwater. Considered by many of his peers as one of the most acknowledged Masters of Light working today, Chris is a frequent guest speaker and instructor at workshops and conventions on several continents.

Chris is the author of numerous books on photographic lighting, including the bestselling *Master Lighting Guide for Portrait Photographers* and others published by Amherst Media, as well as books on Photoshop techniques and the Canon camera system.

View the companion blog to this book at: http://studiolightingphotography-grey.blogspot.com/
Check out Amherst Media's other blogs at: http://portrait-photographer.blogspot.com/
http://weddingphotographer-amherstmedia.blogspot.com/

All rights reserved.
Published by:
Amherst Media®
P.O. Box 586
Buffalo, N.Y. 14226
Fax: 716-874-4508
www.AmherstMedia.com

Publisher: Craig Alesse
Senior Editor/Production Manager: Michelle Perkins
Assistant Editor: Barbara A. Lynch-Johnt
Editorial Assistance by Sally Jarzab, John S. Loder, and Carey Maines.

ISBN-13: 978-1-58428-271-6
Library of Congress Control Number: 2009903887
Printed in Korea.
10 9 8 7 6 5 4 3 2 1

Contents

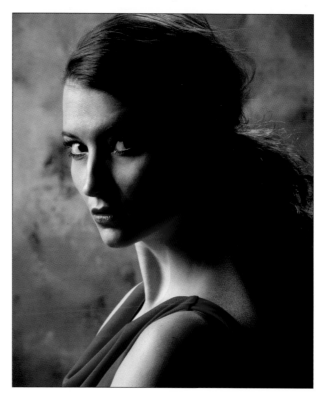

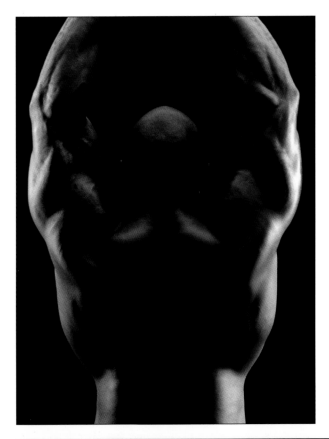

KUDOS

There is a great deal of work, and a large number of people, involved in a project like this book. While it's a labor of love for me, it was a commitment of time for them, and their efforts are much appreciated.

Many thanks to my models, Faayo Adam, Denise Armstead, Tristy Auger, Sandra Avelli, Katy Becker, Lola Bel Aire, Michael Dane, Laurel Danielson, Kimberly Dohrer, Bill Foster, Gerry Girouard, Bill Gladden, Cassie Glover, Tammy Goldsworthy, Molly Grace, Christine Grether, Jennifer Hammers, Amanda Harris, Arika Inugami, Courtney Johns, Brooke Keys, Erin Kromer, Jennifer Lindner, Joanna Mickelson, Alan Milavetz, Jessica Nyberg, Michael Ostman, Nichole Parrish, Carrie Poehler, Madge Plasto, Lucia Radder, Jennifer Rocha, Sehata, Margot Scheltens, Aleta Steevens, Ruthie Stein, Katie Thomey and her beautiful children, Alissa Tousignant, Keith Williams, and Sahar Zamir. Thank you for your time. Thank you for your talent.

To the hair and makeup artists, the unsung heroes of the studio: thanks to Sandra Avelli, Nicole Fae, and Sarah Morrison. Your work is terrific, and you make my life easier every time we work together.

Thanks to my buddy Joey Tichenor for the author photo. Joey's doing some very fun, creative and interesting work that you can check out at www.JTichenor Photography.com.

Special thanks to Sue, my beautiful wife, who puts up with my ridiculous schedule time after time, and to our daughter, Liz, who does the same.

Introduction

Since I committed to digital I've seen more changes in our industry than I saw in the first twenty years of my career. For instance, I used to joke (read: lament) that every time the camera industry made a major technological breakthrough like auto flash, TTL average and spot metering, or auto focus, I would have to deal with at least a dozen new competitors, all grimly determined to undermine my market share. Well, I dealt with them just fine. Many of the successful became friends (but rivals), while the unsuccessful moved on to other venus, some of them making terrific hamburgers to this very day.

When digital photography took over, photographers came to understand that the learning curve was steeper than many imagined or were led to believe, but the biggest error most photographers made was in applying analog techniques to digital photography. Many photographers learned just enough to put the equipment to work; this was understandable given the cost of the gear and the need to put food on the table. Those photographers did not foresee that the necessary investment in image manipulation software to fix simple errors would have a devastating effect on personal and family time.

The simple truth is that every technical mistake can be avoided by applying just two things: knowledge and control.

About This Book

Professional lighting, or should I say, lighting like a professional, is largely a matter of taste and practice. Your taste will determine what wardrobe, background, and composition you'll use for your images. Practice will determine your selection of lighting style, the equipment you'll use and, ultimately, your success. Yes, that's correct. Visual success for a photographer is mostly the result of practice. Shoot, shoot, shoot because, with digital, it's free, free, free. Even if you're not being paid for your work, you still need the practice. Practice leads to innovation; it's that simple. I've been shooting paying jobs since I was fourteen, a long time ago, but still look forward to several practice shoots every month. Those sessions are where I feel no creative restraints and can simply play with my toys. Even if the images are not as good as I'd expect, perhaps even awful, the more successful scenarios are either tried again until I'm comfortable enough with them to incorporate them into my bag of tricks or left behind in the dust. Of course, these rejected scenarios are put away in a special file drawer in my head. Failure is a wonderful reference.

With this book, I'd like to provide you with some ideas for both your practice sessions and paying jobs, and I hope you'll look at each chapter with that in mind. Read, play, and learn. I know you'll find your own bag of tricks will be significantly enriched.

That said, there are some principles of digital photography that you must be aware of before we begin, as well as some choices you'll have to make. For those of you who are beginning your careers, Part 1 provides insight into the things you'll need to understand by the time you end your careers, hopefully retiring to your personal tropical island in some chain not serviced by a major airline. There are many, many reference books, written by great photographers, who use their entire volumes to explain how little details work. I have only the space to write about a few, certainly important but certainly not complete, so I encourage you to read as many other sources as you can. We all have our own ways of shooting. You can study mine as much as you wish (and I hope you do), but your results will be, and should be, different from what I produce.

For those of you who are working pros who understand the constraints of digital but are just looking to add a few tricks to your lighting repertoires, you may skip ahead to Part 2—at your own risk, of course.

1. Color Spaces and File Formats

Though you've picked up this book to learn how to effectively light animate and inanimate subjects in your studio, the quality of your final photographs is dependent, in part, on correctly selecting some key camera settings. (Don't worry; we're picking up steam now and will turn our attention to metering, quality of light, and lighting gear in the next few chapters before delving into some case studies.)

Color Spaces: RGB vs. sRGB

A question that's come up frequently in my workshops and classes is, "What color space should I be shooting in?" The answer is, "It depends on what you're shooting for." That's not an artful dodge, it's the truth in digital terms.

Your camera will offer at least two choices, Adobe RGB (1998) and sRGB. Both are viable, but there are differences you should be aware of. Adobe RGB (1998), which we'll simply call RGB from now on, is a large color space (also called a "gamut"), which is capable of recording more colors than sRGB, a smaller color space. At first blush you'd think that RGB would be the way to go, right? Isn't it better to have more colors than less? It is, if your work is being produced for mechanical reproduction, like this book. You see, when something like this book is produced, images appearing in it are converted to yet another color space, CMYK (Cyan, Magenta, Yellow and Black), that's even smaller than sRGB. It's necessary for a CMYK reproduction to have as much color as possible at its disposal before conversion, so that the smaller space will "see" as much color as it can.

The sRGB color space is used for images that will be sent to a lab for printing as 8x10s, 5x7s, whatever. The printers used by the labs are sRGB devices themselves, incapable of seeing the entire RGB gamut, much less reproducing it. The machine may not even recognize an RGB file, and an operator will have to manually convert the images to sRGB before sending the order back through the printer. Some labs charge extra for this service.

Image 1.1—A graph of the three color spaces and the range of colors they can reproduce. Adobe RGB (1998) is the largest; sRGB fits inside of it. CMYK is the smallest color space.

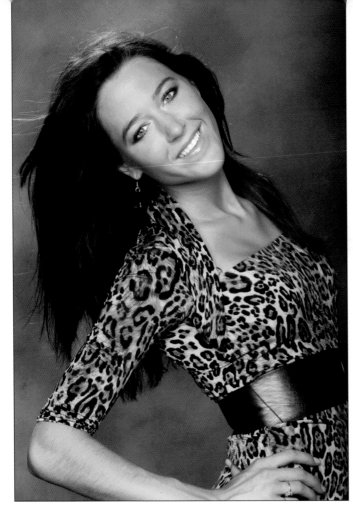

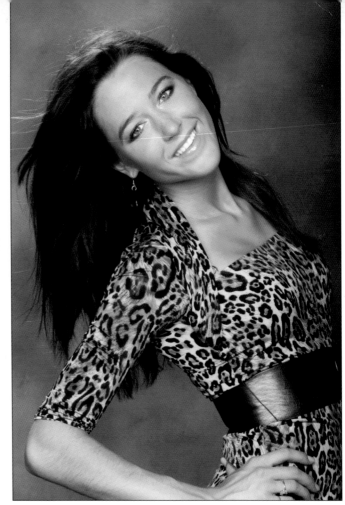

Images 1.2 and 1.3—*Can you tell the difference? One of these is a RAW file processed "as is," and the other is a JPEG straight off the memory card. The answer can be found at my web site; just go to www.Christopher Grey.com/Quiz. By the way, this is the only shot in the book that began as a RAW file.*

The Internet is also an sRGB device. Images posted on the web should be sRGB images or they will look flat and slightly off-color.

Unless you have one of a very select (and expensive) group of monitors built for the RGB color space, you won't be able to see the extra colors anyway. Your monitor is an sRGB device and can't see beyond those colors, even if you shoot files in RGB.

The bottom line is there's nothing wrong with the sRGB space and, if you shoot to have your pictures hung on walls or framed on mantles, sRGB is the space to use.

File Formats: RAW vs. JPEG

Entire books have been written about this topic, and it's akin to opening a can of worms. I have only a few words to say about it, but I hope you'll read them with an open mind. Your workflow, and the amount of time you spend on it, may depend on how these few words impact you.

When you shoot RAW, you create the digital counterpart to a film negative. All the information available to the camera is stored in those files. RAW files cannot be printed "as is"; they must be processed with software such as Photoshop or with software created by the camera's manufacturer. For most applications, the proprietary software is better because it has been engineered for files created by a specific brand of camera. Software like

Photoshop, even though it does a good job, must be generic enough to process files from every manufacturer and so can only work with those factors shared by all cameras.

On the other hand, JPEGs have been programmed, by you and how you set the camera, to process themselves as they are shot and loaded onto the memory card. Once that's done, your options are limited.

Does that mean JPEGs are bad? Absolutely not. Control your exposure and lighting parameters, and JPEGs will do a wonderful job for you without any extra work. I don't allow photographers to shoot RAW in any of my workshops. Once they see that they can control the shoot and the light to very close tolerances they become True Believers (well, some do).

Though RAW files contain more information and exposure latitude than JPEGs, they require additional work from you, and that's the bottom line. Here's an easy workaround option. If you think a shoot will give you trouble or you don't think you can control the situation, shoot both RAW and large JPEGs at the same time. When you load the files onto your computer, take a look at the JPEGs first. If your shots are on the money, burn everything to a disc for backup and work with just the JPEGs. You have the RAW files if you need them.

The beauty of shooting controlled JPEGs is that you can take the files straight to proofs, without any additional processing time, and make minor tweaks later, after prints are ordered and the money is on the table.

The beauty of shooting controlled JPEGs is that you can take the files straight to proofs.

Far and away, the most important accessory in the studio (even in available light situations) is the light meter. Even more important is the ability to read it properly and know how the numbers affect your images. When shooting JPEGs, you have an exposure latitude between ⅓ overexposure and ⅔ underexposure. Images made outside of these tolerances cannot look "normal," even with editing in Photoshop, and once a pixel has been overexposed to a value of 255, there is no way to burn it in or bring it back.

F-stops are symmetrical and mathematical measurements of light. If we begin with an aperture of f/8, for example, opening up the lens by one stop, to f/5.6, will double the amount of light reaching the sensor. Conversely, stopping down the lens one stop, to f/11, will cut the amount of light reaching the sensor by half.

When we power the light to a whole stop—f/2.8, f/4, f/5.6, f/8, f/11, f/16, or f/22—we'll only see a zero next to the f-stop number and we'll know that if we set the camera's aperture to that number, f/5.6 in this case, the exposure will be right on the money (image 2.1).

Digital camera apertures can be set in ⅓ stops, which gives you the opportunity to be extremely accurate when powering your lights for a particular effect. They are shown on your light meter as an extra number just to the right of the primary f-stop number, such as this reading, f/5.6.6. This reading means that the light falling on the subject is ⁶/₁₀ stop stronger (brighter) than f/5.6 itself. If you ignore that extra .6, you will overexpose your images, which you definitely don't want to do (image 2.2).

Image 2.1 (left). Image 2.2 (right).

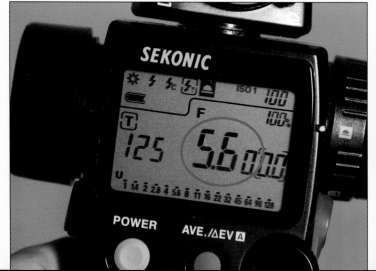
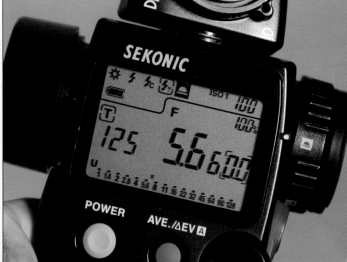

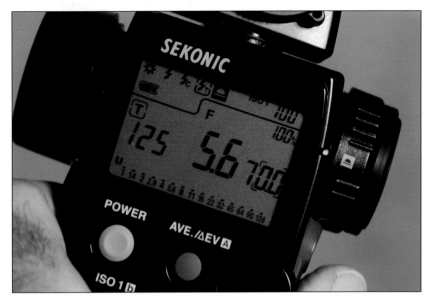

Image 2.3

METER	CAMERA
f/2.8	f/2.8
f/2.8.3	f/3.2
f/2.8.7	f/3.5
f/4	f/4
f/4.3	f/4.5
f/4.7	f/5
f/5.6	f/5.6
f/5.6.3	f/6.3
f/5.6.7	f/7.1
f/8	f/8
f/8.3	f/9
f/8.7	f/10
f/11	f/11
f/11.3	f/13
f/11.7	f/14
f/16	f/16
f/16.3	f/18
f/16.7	f/20
f/22	f/22

So, to be more accurate, you should set your camera to f/7.1 (which is actually f/5.6 +$^7/_{10}$ of a stop). To be *completely* accurate and get the very best exposure, move the main light slightly closer to the subject, move the subject slightly closer to the main light, or power the main light up, slightly, to a light meter reading of f/5.6.7 (f/7.1 on the camera). If your meter is calibrated, your exposures will be right on the money (image 2.3).

Though you are probably aware of the whole stop numbers, you may not understand the new, $^1/_3$ stop numbers and how to translate those easily from your light meter to your camera. The chart on this page shows the correlation.

When working outdoors, you won't have the control over tenths of f-stops as you would in the studio. When that happens, if the reading is +$^1/_{10}$ over a target f-stop, set the aperture to the lower value. In other words, if the meter reads f/8.1, set the camera's aperture to f/8. If the reading is f/8.2, set the aperture to the next highest value, f/9. In either case, the files as they are will be close enough to go straight to proofs and easy to tweak to a more perfect exposure with Photoshop.

3. The Four Qualities of Light

There are four features that are routinely used to gauge the overall quality of the light that makes up an image: color, contrast, direction, and quality (I know that's redundant, but I wasn't the first to dream this up).

Color

The color of light is determined by its color temperature. Does the image look "warm," with a red/yellow color cast, or does it look "cool," with a bluish cast? How it looks is a representation of the white balance setting you've selected on your camera.

For most studio photographers, color temperature is not a major consideration. Our lights, if they are what are known as "hot" lights—incandescent sources that typically burn at 3400K (K is for Kelvin, the guy who originally figured this out)—can be dealt with in the studio (with some degree of success) by simply using the camera's incandescent white balance preset.

For most studio photographers, color temperature is not a major consideration.

Photographers may be chagrined to learn that, as the lights age, the color temperature actually changes and color consistency goes south. What's even worse, at least from a color temperature standpoint, is that bulbs will change color based on use and age. Thus, a bulb that's used more often at full power will age faster than one used less frequently, at full power or otherwise.

For the majority of us who use strobe lights (large electronic flash units controlled by a generator and not the camera), the daylight white balance preset will do a good job. Strobes are built to produce a consistent 5200–5500K color temperature at their most efficient points, a color temperature that's close to that of bright sunlight at high noon and most, no matter how inexpensive, will do at least an adequate job at full power.

The problem with strobes, at least with the inexpensive variety, is that they tend to "drift," to change color or exposure consistency (or both) regardless of output power.

Though there isn't much to be done about inconsistent equipment, you can stack the deck more in your favor by setting a custom white balance.

Most consumer and all prosumer and professional SLR cameras have a built-in feature that allows you to nullify off-color light, and it's an easy feature to use. Simply set the main light (the most important light in the scenario), meter it, set the camera, and take a picture of a commercially available neutral white or gray target. Use the camera's custom white balance (CWB) option to tell the camera that the light it sees is actually neutral. This means you can "persuade" the camera that light with a color temperature of, say, 7000K is actually 5500K, and the camera will add appropriate digital filtration to change the bad light to good, neutral light.

The feature is easy to use with any camera system, but you'll have to read your instruction manual (omg, noooo!) to learn how your camera does it.

Please note that a custom white balance cannot help strobes whose color temperature drifts over the course of a shoot. Your only option is to get better gear. Sorry. Those bargain strobes aren't such a bargain, after all.

Why not just use the auto white balance (AWB) setting? After all, it *is* automatic, right? When you make an image with auto white balance, the camera's computer looks at each image as it's made, compares what it sees with what it has been programmed to "think" is correct, and makes whatever changes it deems necessary. This means the color of the final images can be skewed, depending on whether or not there are strong colors in the scene that the camera thinks must be adjusted. If your subject is wearing an outfit of strong color against a neutral background, or vice versa, the camera will attempt to nullify some of the strong color by adding its complementary color to the file. This can change the color of the background and the subject's flesh tones. When that happens, you're skewed (images 3.1, 3.2).

Does this mean that all studio photography should be made with a neutral white balance? Not at all. You're free to make adjustments to the white balance anytime you wish if those adjustments will help you realize your vision. Most prosumer and professional cameras have the capability to set the color temperature to virtually any point from at least 2500K to 10,000K. If you shoot under constant conditions (like strobes in a studio), you can alter the look of that constant light to change the emotional impact of the image. Note that, in the studio, the alterations are not being used to neutralize light, only to alter it. In the field, the use of a specialized device, a color temperature meter, would allow you to measure the ambient color temperature of any source, to which you could apply the appropriate color temperature and neutralize the light. If you tell your camera that you wish to set the temperature to 10,000K (when shooting with daylight balanced light), it will actually throw enough red and yellow into the mix to counteract what it has been told is bad light. In other words, it works the opposite of rational thinking (images 3.3, 3.4).

All prosumer and professional SLR cameras have the ability to nullify off-color light sources built right into them.

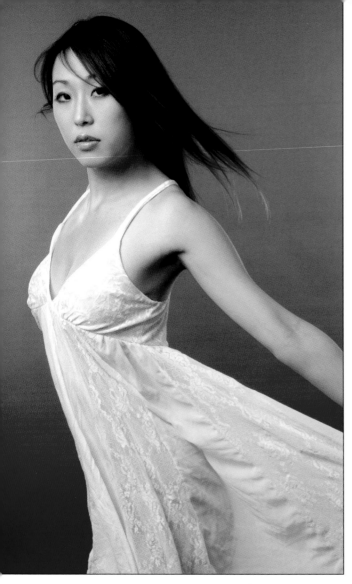

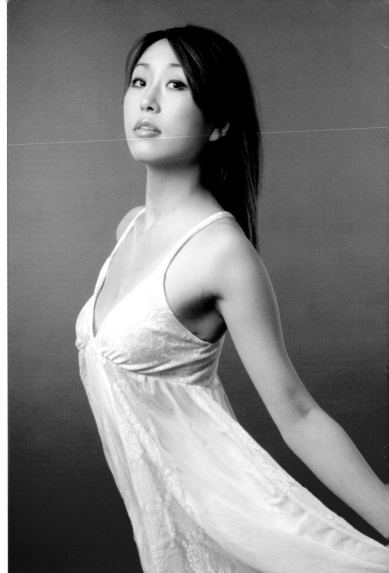

Image 3.1—(top left) This shot was made using auto white balance. The camera saw the strong red background and attempted to balance it against the model's tones. The result is tones diluted by cyan. *Image 3.2*—(top right) A custom white balance will only measure the color of the light, adding whatever correction is necessary to make it neutral. The result is perfect flesh tones against a correctly represented red background. *Image 3.3*—(bottom left) Setting a color temperature of 2500K will produce a very "cool" image. *Image 3.4*—(bottom right) A color temperature of 10,000K will give your images an extreme degree of warmth.

Image 3.5—(left) This image was shot with a normal custom white balance. *Image 3.6*—(center) This image was skewed toward the cool tones. *Image 3.7*—(right) This image was skewed slightly toward the warmer tones.

It may also be possible, via a custom function or menu option, to shoot a white balance shift "bracket" (one or three shots of various color balances for every frame you make). This function may be more valuable than selecting a specified color temperature because you can shift the color instead of the color temperature, especially if you find a color temperature that suits your vision and personal style. As always, you're encouraged to play with this camera feature. Go for it (images 3.5–3.7).

Contrast

Contrast is the difference between the highlights and shadows in an image. More specifically, the degree of contrast is determined by how quickly the highlight areas transition to shadow.

Contrast is determined by a couple of factors, the most important of which is the size of the light source. A small source, relative to the subject, throws hard light that transitions quickly from light to dark. Though the sun is huge, it is so far from us that its relative size is diminished. As such, in an open sky, it provides very contrasty light and deep, sharp shadows.

When the sky is filled with high, thin clouds, it acts like a huge softbox. When the sun's harsh light is filtered by the clouds, light is softer and the shadows are lighter. If the clouds are thin enough, and the sun is behind the subject, you may see a highlight, like a hair light, behind the subject. This is perhaps the most beautiful light you'll find.

Contrast is determined by a couple of factors, the most important of which is the size of the light source.

Under heavy overcast, the color temperature will change, of course, becoming cooler in its look. Overall, the effect will produce flat, pasty flesh tones because there will be a major shift in color temperature to the cool side and because the light is impressively flat. Flat light is incapable of producing significant contour, but that doesn't mean you shouldn't shoot. A custom white balance will negate any super-cool coloration and give you images with normal color that are very softly lit.

The same principles that govern how the sun influences highlight and shadow hold true for small flash units or studio strobe.

On-camera flash units are always very small. Consequently, the light they throw will create significant contrast and specularity (small, bright and contrasty highlights). To some degree, contrast between highlight and shadow is somewhat reduced because the lights are (usually) placed directly over the axis of the lens. Unfortunately, this placement (which is the best to produce an even light) produces a relatively flat light, without much contour but with specularity. It is not a professional look by any stretch, and not unlike that of a snapshot (image 3.8).

The look of images made with accessory flash units will benefit from third-party modifiers such as my favorite, the Ultimate Light Box (www.harbordigitaldesign.com) (image 3.9).

The situation is the same in the studio. Modifiers such as umbrellas and softboxes will produce softer light by working as a larger source than that obtainable from a simple parabolic reflector, the modifier almost always included in the sale of a strobe unit.

Image 3.8

Image 3.9

Image 3.10

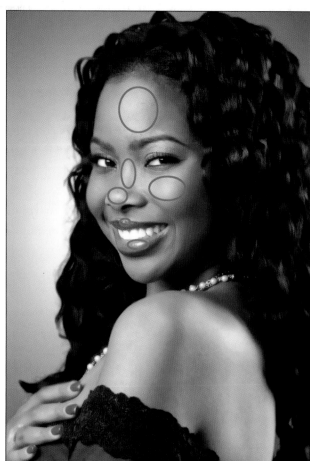

Image 3.11

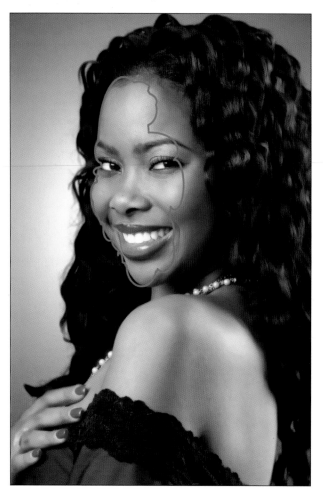

Image 3.12

Image 3.13

Image 3.14

When we look at a photo of a face, we should see three separate regions of information.

Here's how it all works in a practical application:

When we look at a photo of a face, we should see three separate regions of information, each contributing to our perception of contrast (image 3.10, facing page).

The first region is called the specular highlight, the brightest portion of any photograph. The specular highlight is actually the direct reflection of the light source as determined by the texture of the surface. The smaller the light, the brighter (and sharper) the specular highlights. The main light for this portrait was a medium softbox, so the speculars in the image are somewhat diffused but still noticeable. Note that specular highlights are not necessarily a bad thing. When they're properly dealt with, via lighting or makeup, they add to the dimensionality of the image but are still very noticeable, especially on smooth or glossy surfaces like lips (image 3.11, facing page).

The second region is called the diffused highlight. This is the most information-rich area of the image and effectively imparts a feeling of dimensionality to the subject, especially the face. Remember that a portrait is a two-dimensional representation of any subject, so it's important that we light our subjects to create the illusion of a third dimension (image 3.12, facing page).

The third region is called the transition zone, and it's in this area that the diffused highlight turns to shadow. The actual shadow is not considered a zone by itself, since information in shadows is typically not critical. Note that the three zones can be found in any other light (the light on this woman's hair and back is a good example), but it is the main light with which we should be most concerned (image 3.13, facing page).

When smaller sources are used, the look of the three zones will change. Specular highlights will be smaller and brighter, the diffused highlight will create sharper and deeper shadows, and the transition zone will be shorter (image 3.14). The opposite is true of sources larger than the medium softbox I used, or if the source is closer to the subject.

Image 3.15—(left) Short light. When the face is turned from ¼ to ⅞ away from the camera and lit to illuminate the side opposite the camera. The triangle of light on the unlit cheek that distinguishes loop or closed loop light is not necessary, but it may be used as a compositional element. *Image 3.16*—(center) Broad light. When the face is turned ¼ to ⅞ away from the camera and lit to illuminate the side facing the camera. It is not necessary to create a triangle of light on the unlit cheek to indicate loop or closed loop light, but it may be used as a compositional element. *Image 3.17*—(right) Loop light. The main light is angled so the shadow of the nose follows the inside line of the cheek, forming the start of a loop under the cheekbone.

Direction

Direction is the angle of light to the subject. It is sometimes possible to change the direction of the light for a more flattering result, either through posing or modifier changes.

The most successful images appear to be lit by a single source, even if the lights are aimed at the subject and background from different angles. This is a concept that's deeply rooted in our collective subconscious because the sun has been our primary light source for eons before torches or candles. If we lived on a planet with multiple suns, we could light our subjects with shadows going in every direction—up, down, or sideways—and our clients would love them. That's not the case, however, which is why the single source look is best, at least for this world.

The principle of attractiveness also applies to images made under sunlight. The primary reason photographers choose to shoot before 10:00AM or after 4:00PM is that the shadow thrown by the sun is more graceful than at other times of the day. This is most true in the summer months, when the sun is highest in the sky and the shadows are deeply angled and contrasty. When the sun rises or falls, the angles change to something more attractive and, as the seasons change, so will the angle of the sun; the amount of usable time (for the best shadow angles) will also increase or decrease. The angle of the sun's shadow depends, of course, on where you're located relative to the equator.

 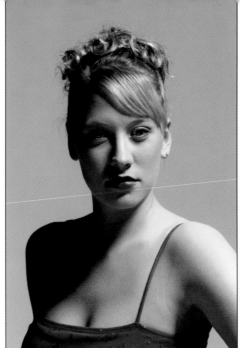 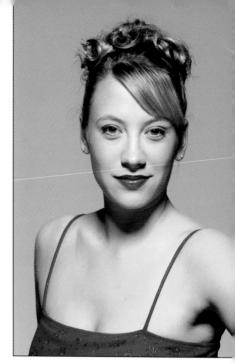

Image 3.18—(left) Closed loop. The shadow from the nose is broader and follows the inside line of the cheek but connects with the side shadow to form a closed loop. Note that both eyelids are illuminated. *Image 3.19*—(center) Rembrandt light is characterized by a highly placed main light and a long shadow. A variation on closed loop lighting, Rembrandt lighting shadows the opposite eyelid while still creating a triangle of light on the cheek. Although it's beautiful for some images of women, it's probably more effective when used on men because it is a moody and "brooding" light. *Image 3.20*—(right) Butterfly light, also called Dietrich or Paramount light, is produced when the main light is placed directly above the lens, resulting in a butterfly-shaped shadow under the nose. There is no set size to the shadow; the length is at the photographer's discretion and is controlled by the height of the main light.

In the studio, the direction of the light is totally controllable by the photographer but should still appear to be dominated by a single source (though there may be several lights in play).

In order to achieve proper direction, portrait photographers need to pay attention to the position of the light relative to the shape of the subject's face as well as the height of the source. Height and placement will allow creation of any of the six classic lighting styles (illustrated above), all based on the main light.

Quality

The quality of light refers to its characteristics as it falls upon your subject. Is the light hard, with distinct shadows and specular highlights? Is it soft with luminosity, or is it just soft and "mushy?" Does it suit your subject and your vision? These are questions you'll have to investigate and answer before shooting.

You'll find several chapters of this book devoted to the quality of light from different modifiers, explaining how they work at varying distances or under different circumstances. I'd suggest that you play with your gear and with as many of the alternatives I've written about as possible.

Speaking of gear, here's an overview of what I'll be working with over the course of this book. If I haven't mentioned it before, I'm fully aware that many of you will not have access to the variety of tools that I have in my studio. I'm lucky to have been exposed to some of the best equipment manufactured today, and even luckier to have been able to acquire it. If you see a piece of gear you think you'd like to own, I'd recommend you rent or borrow it before you buy, work it like a rented mule while you have it, and then make an educated decision as to whether it would be in your studio's best interests to own it or not. Good stuff is expensive but worth it if, and only if, you can use it to increase your bottom line.

Softboxes

Large Softbox. In my opinion, softboxes are the most valuable modifiers you can have in the studio. My largest is 4x6 feet, and I have two of them. I use both of them quite often, in the same set, along with gobos to keep the light directed where I want it. When placed close to the subject, within a couple of feet, the light is extremely soft but with rapid falloff. Based on my calculations (see chapter 5), the optimum working distance for a large softbox is 10 feet from the subject. Properly used, a box this size can be very effective for many lighting scenarios (image 4.1).

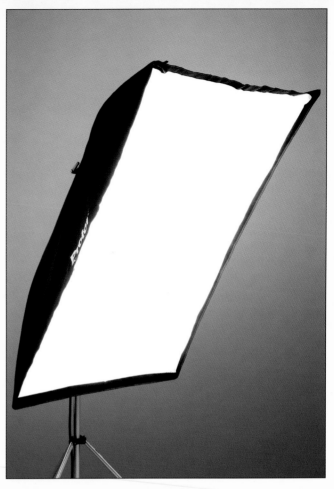

Image 4.1

 Medium Softbox. The most used softbox in my arsenal is the 3x4-foot (medium) softbox. I have two of these also and use them in much the same way as the larger boxes. They are valuable when working in closer quarters, as their optimum working distance is 7 feet. The same Inverse Square Law applies (detailed in chapter 5), of course, and the principles of use are the

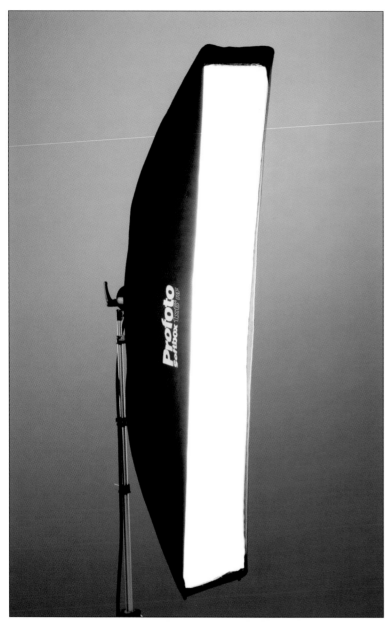

same. I use medium softboxes as main lights more than any others, and I'm certain you will too.

Small Softbox. Small softboxes—2x2 or 2x3 footers—are invaluable for use as single subject hair lights, background lights, or underlighting fill. They can also be used as a main light, of course. When placed very close to the subject, the falloff (the decrease in light intensity as the distance from the light source increases) is rapid, as it always is at close distances, but the spread of the light is minimal because the source is so small relative to the subject.

Strip Lights. Strip lights are a somewhat specialized accessory; they're long, narrow softboxes engineered to produce an even output throughout their entire length. I have several 1x6-foot strip light softboxes that I use frequently as accents, side lights, background lights, or hair lights. They are not cheap and require a special speed ring that not all strobe manufacturers make, but they produce a light that's beautiful and hard to define. The manufacturer of my gear, Profoto, is one of the few making a 1x6-foot box. Should you decide to purchase them and you don't use Profoto equipment, please make sure your strobe's manufacturer makes a speed ring that will accommodate them (image 4.2).

Image 4.2 **A Final Note on Softboxes.** Quality softboxes have an additional layer of diffusion, an internal "baffle" layer of nylon that diffuses the light even more before it reaches the front of the box and exits. When buying softboxes, be sure to check that the corners are heavily reinforced to withstand the constant pressure from the rods that connect the box to the speed ring.

Umbrellas

Umbrellas spread light by acting as a reflector. There are two types of umbrellas generally available at your local camera store. The first is a basic reflective umbrella wherein the light, fitted with a parabolic reflector, is aimed away from the subject into the umbrella. The spread of light will depend on the size of the umbrella, and the contrast of the light will depend on the

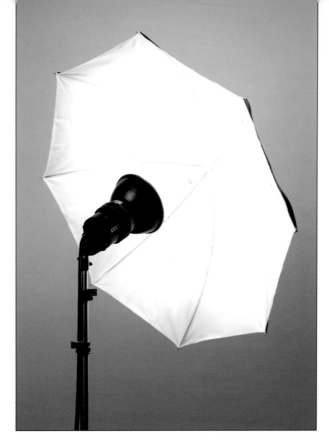

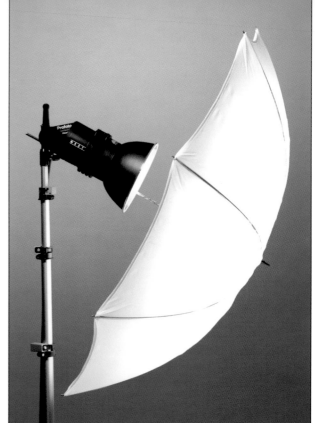

Image 4.3 Image 4.4

reflective surface. Umbrellas come with either a white or silver surface. Sil-
ver will provide a slightly different look than white (image 4.3).

The other widely available style of umbrella is called a "shoot-through"
umbrella. Instead of a reflective surface, the umbrella is made of translu-
cent nylon and the strobe head is aimed at the subject, shooting its light
through the fabric to the subject. It is, essentially, a softbox, though its
light is not quite as soft because there's only one layer of diffusion. It's not
as controllable as a softbox, either, as umbrella light
tends to spray in all directions. Use a gobo to block light
from any areas where it's not wanted (image 4.4).

Reflectors

Basic parabolic reflectors are usually provided by the
manufacturer when a strobe head is purchased. Most are
6 or 7 inches wide and designed to throw a hard light
evenly over the subject. These are not generally recom-
mended for portraiture (there are exceptions, of course)
but are used along with umbrellas or as fill or bounce
light (image 4.5).

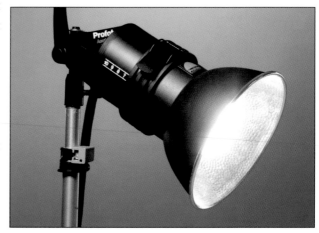

Beauty Bowls. Beauty bowls, also called beauty dishes, are large re- Image 4.5
flectors that have a baffle in front of the strobe head that reflects direct
light back to the sides of the dish. The net result is a direct but softer light
than one would get with a basic parabolic. Beauty bowls are usually at least

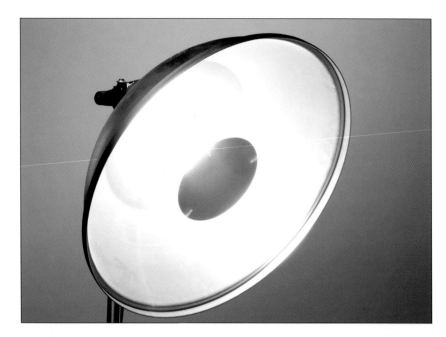

18 inches in diameter, though there are some on the market that are 24 inches or larger. They are pricey, as are their accessory grids, but the cost is more than worth it for the quality of light they produce. Some manufacturers' beauty bowls allow the center diffuser to be removed to produce a more contrasty light source.

I use beauty bowls in a number of ways, but I find them especially valuable as hair lights when used with a grid (image 4.6).

Panels and Collapsible Reflectors. As you will see, I use a number of reflectors in my work. My favorites are bookends, two pieces of 4x8-foot foamcore taped together along a common spine. You will see many examples of how I work with these—especially my favorite and my own invention, the bookend bounce—in chapter 15 (image 4.7).

I also use several of Lastolite's collapsible reflectors. I've found these wonderful gadgets, which are usually meant for bouncing light when working outdoors, are very useful for studio work (image 4.8, page 24).

Grids

Grids are honeycomb-like devices, about ⅜ of an inch thick, that reform light that passes through them to a straight line, expanding a specified amount from its center. Depending on the manufacturer, sets

Image 4.8

of grids for parabolic reflectors may be purchased individually or in sets, in a range of 5 to 40 degrees. (Grids for beauty bowls are not as numerous.) The specified degree means that, when a parabolic is fitted with, say, a 20 degree grid, the light will expand from the center of the reflector at 20 degrees.

Grids can be used to create spotlight effects, as controlled hair or accent lights, or to skim across a surface. One of the great features of grids is that they can throw bright accents from behind a subject yet keep light from striking the lens, which could produce flare (image 4.9, facing page).

Accessory Arms

I've found accessory arms, essentially short poles that clamp over light stands, to be invaluable tools in the studio. I have a number of these, under the Avenger label, that do a great job for me. Some are engineered with clamps for reflectors, some are just rods to which I can attach reflectors, flags, or whatever. Depending on the weight of what is being attached, a sandbag or counterweight may be necessary to keep the stand from falling over (image 4.10, facing page).

Image 4.9

Image 4.10

In Closing

Astute readers will realize that I've written about some of this equipment before. I apologize if I was repetitious, but not everyone reads everything I write (as valuable as I think it might be). As I wrote in my previous book, *Master Lighting Guide for Portrait Photographers*, there are no new lighting styles, only new ways to work with them. My intention is to spark your creativity with the knowledge I've gained through my years of work and play, and I certainly hope you'll find my text as useful to your work as I've found the research a spark for my own.

Study this book. Learn. Adapt what I've shown you to your personal style. Make me proud.

5. Specularity and Depth of Light with Softboxes

Softboxes have been a studio staple since strobes became affordable. The light is clean, natural looking, and allows for open shadows that give the light a unique look—or does it? As we will see, light from a softbox is not necessarily soft. Varying the size of the softbox and the distance from the softbox to the subject can have a profound impact on the look and quality of the light.

Finding the Best Light

To prepare for this test, I set a mark at 5 feet from the background and positioned a chair so that my model's face would rest over that mark. From there, I laid tape marks at 18 inches, 3 feet, 5 feet, 7 feet, 10 feet, and 15 feet from her mark. In each test, the front fabric of the softbox was centered over the distance marker. The only other light was a kicker at camera left to separate her shadow side from the background.

Amanda Harris, lead singer for the very hot band GingerJake, was in the studio for something a little more glamorous when she was pressed into service to demonstrate this particular concept. She's a beautiful woman with an arresting look, perfect for her career and perfect to show how the size of a modifier and the distance between that modifier and the subject will affect the look of an image.

My first setup used a small (2x2-foot) softbox set at 18 inches from the model's face. Because she's so close to the light and the modifier is rather small, the light falls off quickly. Her face looks great, even with the deep, soft shadow, but the light has already become weaker by the time it reaches her chest. This is the principle of the Inverse Square Law, which states that light that travels twice as far from point B to point C as it does from point A to point B is only $\frac{1}{4}$ as strong at point C as it is at point B. Simply stated, when a light is placed very close to the subject it will lose its potency (fall off) very quickly. Even so, the feel of the light is very soft because the source is so close (and correspondingly large) to the subject. Note too that there is almost no carryover of light to the background because it has lost so much intensity so quickly (image 5.1).

Softboxes have been a studio staple since strobes became affordable.

Image 5.1—(left) 2x2-foot softbox at 18 inches. *Image 5.2*—(center) 2x2 softbox at 3 feet. *Image 5.3*—(right)—2x2-foot softbox at 5 feet.

The smaller the light source, the more defined the specular highlight.

Moving the light back to 3 feet gives us the best look between a close source and an even spread. Note that the shadows are still soft and deep but that the brightness of the light is pretty equal across her entire front, producing even skin tones and terrific detail in her black dress. This is the start of the "depth of light" phenomenon, where light carries essentially the same exposure across a longer distance (image 5.2).

At 5 feet, the light from the small softbox shows the first signs of specularity in the bright highlights on her forehead, cheek, and nose. A specular highlight is a reflection of the light source as defined by the surface it is reflected from. The smaller the light source, the more defined the specular highlight—especially with digital imaging. If you've ever used an unmodified flash from a distance greater than 3 feet, you've seen distinct, contrasty, and specular highlights that would have been much less significant had you been shooting color negative film. Note that in this image, the background is beginning to lighten as the source is moved farther from the subject. The depth of light is increasing (image 5.3).

At 7 feet, and from here on, there will be minimal increases in the amount of light to the background. Because the strobe's variator has been adjusted to produce a consistent meter reading, the face looks the same in the three images, with variations only due to the angle of incidence. But, if we look at the exposures made at 7, 10, and 15 feet, we can see a few important changes. First, and most important, is that the original small softbox has become a truly small light source, not unlike an accessory flash. The shadows become harder as the flash distance increases and the specu-

Image 5.4—(top left) 2x2 softbox at 7 feet. Image 5.5—(top right) 2x2 softbox at 10 feet. Image 5.6—(bottom left) 2x2-foot softbox at 15 feet. Image 5.7—(bottom right) 2x2-foot softbox at 15 feet. Note how sharp the specular highlights are.

lar reflections increase in contrast and sharpness. Finally, at 15 feet, the light is flat but shows hard characteristics because the size of the source, relative to the subject, is very small (images 5.4–5.7).

This detail of the last portrait will show more clearly just how sharp the specular highlights actually are, especially in the folds around the eyes.

The most popular softbox size is, arguably, 3x4 feet (medium). Manufacturers may vary the size a bit, but the general dimensions are the most versatile for studio work. The size can't be beat for general portraiture, and it is also perfect for small product and food setups.

Just like the smaller units, results from the 3x4-foot softbox depend on the distance of the light to the subject. Although falloff is less, due to the increased area that makes the light broader and softer, the light is subject to the same laws of physics. Here's how it works:

At 18 inches, the quick falloff is very similar to that from the 2x2-foot softbox. A closer look reveals that the spread of light is more even across the full height of the model. Because of the greater apparent size of the

WEDDINGS

Although I don't shoot more than a few weddings a year, I find a medium softbox to be a perfect main light for the altar group shots. I'll place it high over the camera so that my shadow will not affect the shot and far enough away so that the exposure, the depth of light, is consistent over the posing area. Unless I really need to get in tight I'll let my zoom do the work of composing the images.

source, more light wraps around Amanda to reach the background. Also, the greater surface of the box makes the background a bit brighter because more light can wrap around the subject (image 5.8).

At a distance of 3 feet, minor discrepancies in the depth of light begin to disappear, and the overall effect is more even. There are no evident specular highlights (image 5.9).

When the softbox is moved back to 5 feet, the diffused highlight, the most information-rich portion of the image, begins to acquire modeling, highlights, and shadows that better define the model's shape (image 5.10).

Move the softbox to 7 feet, and the effect is just short of magical. The shadows open up, revealing detail and shape as the light wraps around the subject. Speculars begin to show themselves on the forehead and cheeks but are unobtrusive enough to only add visual interest and a more three-dimensional shape in our two-dimensional plane. The background receives a healthy dose of light so that all portions of the form are readily apparent and easily perceived. This is as close to a perfect two-light portrait as one might get with this lighting scenario (image 5.11).

Image 5.8—(top left) 3x4-foot softbox at 18 inches. *Image 5.9*—(top right) 3x4-foot softbox at 3 feet. *Image 5.10*—(bottom left) 3x4-foot softbox at 5 feet. *Image 5.11*—(bottom right) 3x4-foot softbox at 7 feet.

Image 5.12—*(top left) 3x4-foot soft-box at 10 feet.* *Image 5.13*—*(top right) 3x4-foot softbox at 15 feet.* *Image 5.14*—*(bottom) Detail photo.*

The shadows open up, revealing detail and shape as the light wraps around the subject.

When the main light is moved to 10 feet from the subject, we see that specular highlights are beginning to intrude into the visual sense of the image. The 3x4-foot softbox is now becoming a smaller source and is exhibiting those characteristics. Note that the nose shadow is already a bit more defined (image 5.12).

At 15 feet, we can readily see the effects of using a "smaller" source; the light is harder, specular highlights and shadows are more defined, and the overall look is a bit flatter. Note that the specular highlights appear less distinct, especially in the detail photo (images 5.13 and 5.14).

Some photographers/instructors have taken the position that a 4x6-foot softbox is inappropriate for portraiture because the size of the source is so large that the shape of the subject's face appears flattened. It may be that those folks have never actually used one. The large size might be overkill, but that's solely dependent on how you like to shoot and what you

like to see. In the hands of the informed, a large softbox is a beautiful tool; it's not only applicable for single subjects but makes a terrific main light for groups.

Due to its size, it was impossible to place my large softbox at 18 inches from the subject. Given the angle of the box, to get the proper nose shadow, poor Amanda would have been suffocated in nylon. Therefore, we'll begin with the softbox at 3 feet from her face. As you can see, the ef-

In the hands of the informed, a large softbox is a beautiful tool.

fect is very similar to that from the 3x4-foot softbox at the same distance, because the strength of the light to the subject is the same as in the previous example. You'll note, however, how flat the light is. It's so broad that there isn't more than a hint of a specular highlight (image 5.15).

At 5 feet and 7 feet, shadows begin to open up as the large source starts to wrap itself around the model. We see no appreciable speculars, though there is a slight difference in the brightness of the background at 7 feet (images 5.16 and 5.17).

When the large softbox is moved to 10 feet, it appears we get the best of both worlds. The specular highlights that begin to appear are just enough to add some contouring to Amanda's face but not too well defined as to

Image 5.15—(top) 4x6-foot softbox at 3 feet. Image 5.16—(left) 4x6-foot softbox at 5 feet. Image 5.17—(right) 4x6-foot softbox at 7 feet.

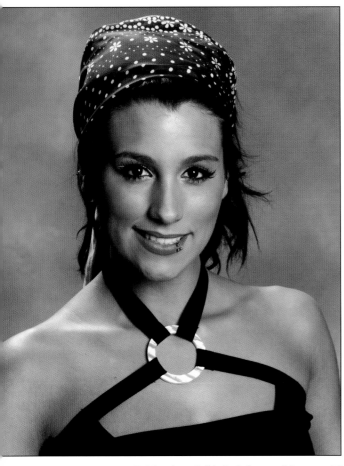

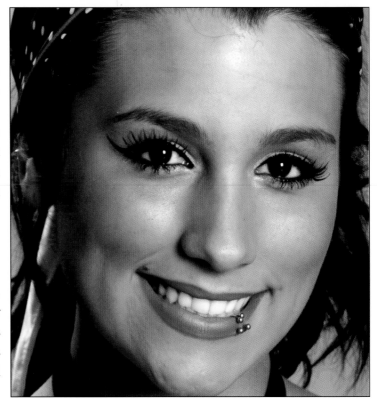

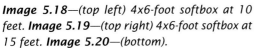

*Image 5.18—(top left) 4x6-foot softbox at 10 feet. **Image 5.19**—(top right) 4x6-foot softbox at 15 feet. **Image 5.20**—(bottom).*

be a nuisance. This could be the best distance-to-subject for a softbox of this size (image 5.18).

Move the large box farther back, and its size (relative to the subject) begins to get smaller. Specular highlights begin to brighten and sharpen and start down the road to ruin (images 5.19 and 5.20).

Summary

So, what lessons have been presented to us?

The smaller the source, the harder the light. And when you move a small source farther away from the subject, the light it throws to the subject is rife with specular highlights that are even more obnoxious in the digital environment.

Depth of light, the property of light that determines its evenness of exposure strength, increases as the light source is moved away from the subject. Remember, light that travels twice as far from the source from where it was originally measured is only $\frac{1}{4}$ as strong when remeasured. You can use this to your advantage to produce dramatic, shadow-rich images by placing the source close to your subject. The closer the source, the faster the light will fall off. Conversely, moving the light farther away (up to a point, after which specular highlights may become a problem) from the subject will result in a more even exposure over the entire image.

Larger sources allow for greater depth of light. Because a larger source will hold its shape over a greater distance, a large source is valuable when you have to light a subject and background with just one light. By moving it farther back you will accomplish two things: you'll illuminate the background in a way that's acceptable to your taste and personal style and you'll keep the exposure even over the distance you need to shoot within. This knowledge is crucial for fine photography of groups.

Add the length and width of the modifier, then place the modifier at that distance from your subject.

Is there an optimum distance for any source-to-subject light modifier? I've heard, read, and forgotten a number of theories over the years, some of them mathematically complicated, always involving the height and width of the modifier but usually requiring the square root of some formula you'd have to go back to school to obtain. Well, here's my theory, and it's easy to figure out if it works or not (just try it): add the length and width of the modifier together, then place the modifier at that distance from your subject. In other words, a 4x6-foot softbox will perform best at 10 feet, and a 3x4-foot softbox will do its best job at 7 feet.

I'm basing my opinion on nothing more than the spread of light and the size (or lack) of specular highlights, and the look of the samples in this chapter. You may like an entirely different look, which is totally fine with me. As always, I advise you to test and play with anything I write about, just to be sure it works for you. If it doesn't work but you like the idea, well, keep playing. It will all make sense to you after a while.

One more point: I deliberately avoided having a makeup artist on set for this shoot, allowing Amanda to do her own makeup. Though her application was quite nice and in keeping with her look, a pro would have powdered her more liberally and kept the shine to a minimum. I know that many of you do not employ a makeup artist on a regular basis, and I wanted to let Amanda's makeup job illustrate the problems you may face when dealing with a typical client.

Of all the accessory light modifiers available to photographers, umbrellas are the least expensive, and their low cost is spread across the board from the smallest to largest size. Consequently, almost every photographer owns at least two and uses them with great frequency. Most manufacturers build umbrellas for studio strobe use but some, like Lowell, use a more heavy-duty fabric that will withstand the stronger, hotter beam from their Tota lights or similar hot lights from other suppliers.

Like the softboxes we discussed in the previous chapter, umbrellas change a small light source, in this case a strobe with a parabolic reflector, into a much broader, softer source. The similarity ends there, however, as umbrellas are an entirely different animal and, as such, the quality of the light they produce is substantially different from that produced by a softbox.

For instance, a softbox will bounce light around inside the box, mixing with itself and changing its direction before escaping through an additional diffuser panel, producing additional softening. The source inside the softbox is actually aimed at the subject. Umbrellas take a concentrated blast of light and reflect it back to the subject in a circular arc that's designed to expand evenly and rapidly.

Umbrellas are available in any of three very popular styles: a white interior (with a black or silver backing); a silver interior that may produce more color contrast; and a white, translucent fabric that's meant to act much the same as a softbox (it's known as a "shoot-through" umbrella because the source is beamed through it from behind, just like a softbox).

There is a fourth style as well, though they may be harder to find and not available in all sizes. "Convertible" umbrellas have two layers of fabric, white against black (or white against white or silver, laminated to black) and allow you to remove the outside layer, effectively changing a "bounce-back" umbrella to a "shoot-through" umbrella.

I've heard arguments over the years as to whether or not a silver umbrella is okay for men (but not for women) and vice versa for white. Although a silver umbrella will produce light with a different quality than

Umbrellas take a concentrated blast of light and reflect it back to the subject in a circular arc.

Image 6.1—(left) Shoot-through umbrella at 3 feet. Image 6.2—(right) Shoot-through umbrella at 6 feet.

Image 6.3—(left) Shoot-through umbrella at 9 feet. Image 6.4—(right) Shoot-through umbrella at 12 feet.

that from a white umbrella, I think either is acceptable, provided the photographer understands both and how either one will impact the look of the finished image. As always, I'll leave the final decision up to you.

For my sample setup, I've placed a 2x3-foot softbox to camera left and aimed it at the background to throw some light into what will be the shadow side of the images. This light may not be too evident, as most of the samples are tightly cropped.

I've also set a strip light softbox high above my subjects to act as a hair light. I've powered the hair light to f/9, $\frac{1}{3}$ of a stop more than my target of f/8 for the main light.

As you will see, there are some interesting differences in how the various umbrella surfaces render detail. For instance, the white umbrella produces smoother, slightly creamier skin tones than the silver umbrella and slightly changes the colors. The shoot-through umbrella produces the most open shadows. As a preference point, I custom white balanced my camera only to the white umbrella. Any color cast that shows in these images would be easily dealt with via a custom white balance, but I wanted you to see any differences that presented themselves.

Though specularity problems exist with umbrellas, just as they do with any light source as that source gets smaller, an umbrella's apparent depth of light is deeper than that of a softbox of approximately equal size, possibly because it's designed to spread out so much faster. The images shown above were made with a 36-inch shoot-through umbrella, at distances of 3, 6, 9, and 12 feet from the subjects (images 6.1–6.4).

I then switched to a 36-inch white umbrella and repeated the exercise. By the way, at a distance of 6 feet, I was attempting to prove that my

theory about optimum working distance for softboxes (height + width = distance) would hold true for umbrellas as well (diameter + diameter = distance). It's a good place to start, but the most important considerations are specularity and shadow density, both of which increase along with light to subject distance (images 6.5–6.8).

Image 6.5—(top left) White umbrella at 3 feet. Image 6.6—(top right) White umbrella at 6 feet. Image 6.7—(bottom left) White umbrella at 9 feet. Image 6.8—(bottom right) White umbrella at 12 feet.

Image 6.9—(top left) Silver umbrella at 3 feet. *Image 6.10*—(top right) Silver umbrella at 6 feet. *Image 6.11*—(bottom left) Silver umbrella at 9 feet. *Image 6.12*—(bottom right) Silver umbrella at 12 feet.

Next up was the 36-inch silver umbrella. Note the slight increase in contrast as well as the minor color shift (images 6.9–6.12).

For the last samples, I swapped out the silver umbrella for a 5-foot diameter white one and set distances at 4, 8, and 12 feet (at 3 feet the side

of the umbrella intruded too far into the frame). This is beautiful light but, because it was made by a different manufacturer, it throws light of a slightly different color. (Always use a custom white balance when changing from one style of umbrella to another, even within the same brand. The quality of the light may be the same, but there's no guarantee the color will be consistent.) However, it does show terrific skin tones and great modeling across the subject's face; it is dramatic at 4 feet and yet shows only minor hardening of the shadows at 12 feet (images 6.13–6.15).

When you try this exercise yourself, remember to increase the height of the light as you move it farther back in order to keep the same shadow position.

Softboxes vs. Umbrellas

So, even though both devices were created to do the same job (take a small, contrasty light source, broaden and soften it), there's quite a difference between how softboxes and umbrellas impact images. Umbrella light expands more rapidly, allowing you to move the device closer to your subject for increased drama while giving the appearance of greater depth of light. Also, quality umbrellas are substantially cheaper than quality softboxes. For the cost of one high-end large softbox, you can buy at least one umbrella of every size and style.

Image 6.13—(top left) Large umbrella at 4 feet. *Image 6.14*—(top right) Large umbrella at 8 feet. *Image 6.15*—(bottom) Large umbrella at 12 feet.

7. Shaping the Background Light

If you don't own grids for your parabolic reflectors, please do yourself a favor and buy a set.

Since I started writing for and speaking to photographers, I've talked a lot about creating lighting scenarios that set you apart from your competition by giving your work a unique look.

A unique look is not solely dependent on the main light, and many photographers don't realize how using modifiers can radically change the look of an image when applied to other lights. In this chapter, with the help of my lighting assistant, Madge, we'll take a look at how we can creatively use grids, one of the most common background light modifiers, to create background light with extra energy and style.

Some photographers feel that a low-placed background light is part of a cookie-cutter approach to portrait lighting, something you might find in every department store image and therefore something to be avoided. I have to disagree. Using a spot of light to add dimension to a shadow side is a classic technique, a beautiful and welcome accent that has been a staple of fine portraiture since the Renaissance.

Background lights are usually placed to illuminate the area behind a subject on the side opposite the main light (that's not a hard-and-fast rule, just a guideline), giving the impression that the light from the main light continued past the subject and brightened some of the background wall. Though that could never happen in real life because light falls off and gets weaker over distance, it's the illusion that counts. Also, the traditional approach is to place the background light on a stand or a boom arm and aim it at the background from the same side as the main light, so that the light's hot spot is closest to the subject, falling off as it travels away. Though there's nothing wrong with that, changing the direction of the background light can produce stunning results.

If you don't own grids for your parabolic reflectors, please do yourself a favor and buy a set. Grids are honeycomb-like devices that come in a variety of sizes (degrees) and force the light to reshape itself into something more like a spotlight. A typical set might include 10, 20, 30, and 40 degree grids, each allowing the light to leave the parabolic reflector at X degrees expansion. Thus, a 20 degree grid will reshape the light so that

it expands at 20 degrees from its center as it exits the reflector. Some manufacturers make even narrower grids, 3 or 5 degree (which produce a pretty genuine-looking spotlight effect). Some, like the 7-inch set sold by Speedotron, will fit a number of other manufacturers' reflectors. You'll need to do a little research to see what fits your own gear or what your manufacturer offers.

Let's begin by placing the background light on a basic floor stand, beyond the camera frame and from the same side as the main light. Make certain that you've placed the light far enough behind the subject (or that the subject is far enough away from the background) to ensure that no light from the edge of the grid will spill onto the subject. Obviously, the narrower the grid, the less likely this is to happen, which also means you

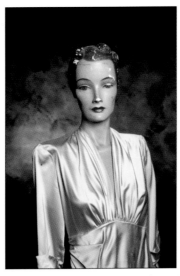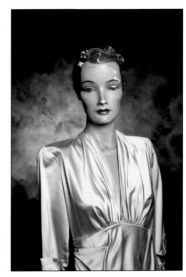

Images 7.1 and 7.2—*(left pair) Strobe with a 10 degree grid, set high from camera right.* ***Images 7.3 and 7.4***—*(right pair) Strobe with 20 degree grid, same position.*

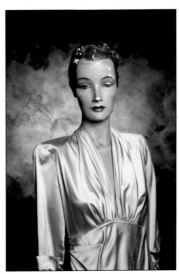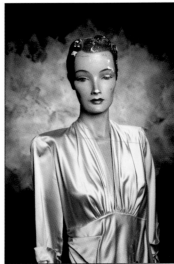

Images 7.5 and 7.6—*(left pair) Strobe with 30 degree grid, set high from camera right.* ***Images 7.7 and 7.8***—*(right pair) Strobe with 40 degree grid, same position.*

Images 7.9 and 7.10—(left pair) Strobe with 10 degree grid, set low from camera left. *Images 7.11 and 7.12*—(right pair) Strobe with 20 degree grid, same position.

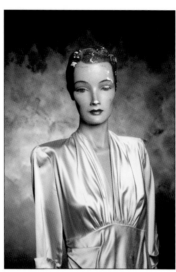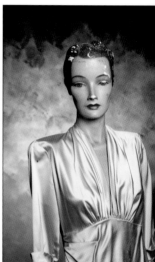

Images 7.13 and 7.14—(left pair) Strobe with 30 degree grid, set low from camera left. *Images 7.15 and 7.16*—(right pair) Strobe with 40 degree grid, same position.

may have to reposition the hot spot with each change, to get its best placement relative to your subject. Set the angle of the strobe high enough to at least match the height of the main light (images 7.1–7.8).

Setting the background light on a low stand (so it shoots upward) and to the other side changes the dynamic of the light, so the hot spot moves into the frame. This can be a very strong accent because it plays against tradition. Though I wouldn't recommend this position for many traditional portrait subjects—family or bridal portraiture, for example, where the lighting needs to be fluid and graceful—this angle and its harder entrance into the frame may be perfect for stronger subjects or for images that should look a little tougher. Personalities who wish to be seen as "on the edge" may profit from this placement, because this background light position gives the viewer a subtle feeling that something is not quite right (but not necessarily wrong) with the light. This psychological twist, the result of simply changing the angle of incidence, can and should be incorporated into your bag of tricks (images 7.9–7.16).

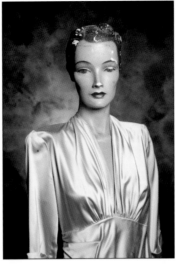

Images 7.17 and 7.18—(left pair) Strobe with 10 degree grid, aimed down to background from boom arm. *Images 7.19 and 7.20*—(right pair) Strobe with 20 degree grid, same position.

 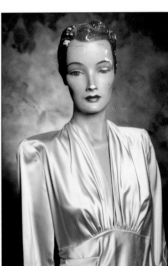

Images 7.21 and 7.22—(left pair) Strobe with 30 degree grid, aimed down to background from boom arm. *Images 7.23 and 7.24*—(right pair) Strobe with 40 degree grid, same position.

A gridspot makes an excellent background light when hung on a boom arm and feathered from the top of the frame to the bottom. Ensure that the hot spot does not contact the background until the bottom of the image frame, if at all. The feathered light will naturally be stronger at the top, so you'll want to angle the light so it just skims the top and gets stronger as the light expands from the reflector (which will keep the actual output pretty even). Spend just a little time checking it with your light meter, adjusting the angle of the reflector or the distance from the background, and remetering the strobe power, and you'll have a light that stays consistent until you want it to get brighter (images 7.17–7.24).

Equally impressive is a light that comes up from the bottom, close to the subject, feathering as it travels.

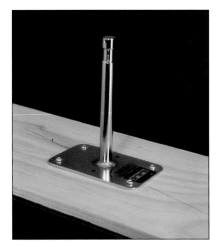

Image 7.25—Nail plate.

Most short light stands (called "shorties," for some odd reason) will place a strobe head about twenty inches from the floor. If you're shooting down at your subject, even a little bit, and your subject is even 8 feet from the background, a shorty will be so tall that it might be in your picture. A less expensive alternative is a piece of cinema and video lighting gear called a "nail plate" or a "baby plate." Nail plates are available in a number of lengths so you can easily get one or two that are tall enough to allow your strobe head to flip upright. The base has machined screw holes, and I'd recommend you mount the base to a piece of plywood for stability. This plate was manufactured by Matthews (www.msegrip.com).

Mounting one or two lights on nail plates allows you to move them behind the subject and shoot the light either straight up or at a slight angle; a very interesting effect.

Images 7.26 and 7.27—Strobe with 40 degree grid, set close to the background and aimed at an angle to the subject.

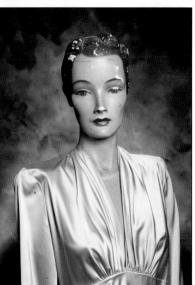

Images 7.28 and 7.29—Two strobes, each with a 20 degree grid, set as an inverted V and metered to equal power.

If you'd like to ring your subject in a circle of light, use the grid of your choice on a light placed directly behind the subject. Position the light quite close to the background, ensuring that that subject's distance from the camera is such that her body appears large enough to obscure the light and stand. A closer light means a more defined edge. Power and meter the light for a circle that is as strong or as soft as you wish, relative to the main light, then bang away. It's a very interesting look, and one you won't see very often, though it is used frequently in Hollywood-style portraiture.

Remember that the strength and apparent brightness of the background light will be influenced by how close the subject and the main light are to the background, as well as how much of the main light's illumination spills onto it.

 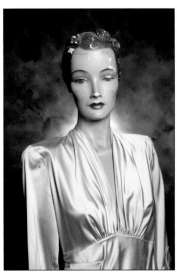

Image 7.30 and Image 7.31—(left pair) Strobe with a 10 degree grid, slightly off center behind subject. *Image 7.32 and 7.33*—Strobe with a 20 degree grid.

 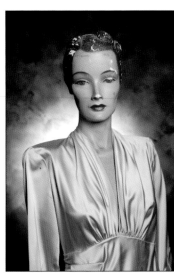

Image 7.34 and 7.35—(left pair) Strobe with a 30 degree grid. *Image 7.36 and 7.37*—(right pair) Strobe with a 40 degree grid.

More Background Light Options

Now that we've taken a close look at using grids to modify background lights, I'd like you to consider using an accessory that most never consider for such an important yet unsung job, and that accessory is the softbox.

Softboxes, when used as background lights, are unlike any other source—broad, splashy, and soft—and using them can give your portraits a unique look. They are somewhat bulky and will sometimes show up in the frame, but one thing you can use in your favor is in-camera cropping. Use your client's body and position to block any part of the softbox that intrudes into the frame so that the modifier will not be seen behind the subject.

Let's begin with a 2x3-foot softbox set on the floor and allowed to find its own angle just by leaning it back onto the head, letting it rest naturally. I've set it to camera left, slightly out of the frame, and angled it toward the center.

This is a totally personal decision, but I'm going to adjust the power of the backlight to equal that of the main light. The question, of course, is where? When a light is angled up over a relatively large area, it will be brighter before the metered area and fall off after the metered area.

Image 7.38 (top). Image 7.39 (bottom left). Image 7.40 (bottom right).

The answer is to look through the lens (or put your head in front of the camera, along the lens axis), and find a spot on the background where you want the light to be equal. Keep your eye on that spot as you walk toward it, then meter for it. For the shot shown in image 7.38, I decided a spot just above Madge's camera-left shoulder was where I wanted it to be.

With the background light metered properly, the background light and the final image look like this (images 7.39 and 7.40).

Should you decide you would like a larger splash of light on the background, simply set your meter point higher in the scene, where the light has started to fall off. The next two images show what happened when the meter point was set near the ear and just above the head (images 7.41 and 7.42).

Another option would be to place the softbox on the same side of the camera as the main light, block the strongest part of the light with a gobo, then feather the light across the background for a very even throw. Notice that for image 7.43, I've placed the strobe head at about the height of Madge's shoulder and angled the light down to the opposite corner of the frame. The piece of black foamcore was snugged up to the softbox, immediately out of frame.

When framed up in the camera, the main light and background light look as shown in images 7.44 and 7.45. In this position, the softbox spills just a little light onto the side of the head. Personally, I like the look, but it would be easy to eliminate it with another gobo placed between the softbox and the model. Also, note that the starting meter point was the same as in the previous example.

Image 7.41 (top left). Image 7.42 (top right). Image 7.43 (bottom left). Image 7.44 (center). Image 7.45 (bottom right).

Another terrific background softbox is the strip light. My favorite is a 1x6-foot softbox; though it's rather expensive, it can be extremely useful for a variety of images and looks.

For the first shot, I placed the box very close to the background wall, then turned it slightly toward the camera, just a little past parallel to the wall and again, snugged up close to the edge of the frame. Placement such as this accomplishes two things: First, the light will fall off quickly because the light is so close to the wall and the edge of frame. Second, angled as it is, it will feather across the wall, maintaining a relatively even exposure as it dims over distance (image 7.46).

Notice how nicely the background light feathers across the wall (images 7.47 and 7.48).

Image 7.49 Image 7.50 Image 7.51

Setting the strip light on the floor produces a different look that's also very attractive. For this set, rather than place the box parallel to the wall, I angled it out slightly, away from the subject, to get more of a spread behind the model (image 7.49).

The effect is both beautiful and fluid (images 7.50 and 7.51).

Barndoors and Mystery Modifiers

Back in the days of hot lights, there were very few modifiers available to photographers that would not combust from the heat of the lamps. Shooters had to bounce hot light off of walls or through noncombustible diffusion material to make it softer or, in the case of background lights, would focus the light through fresnel lenses to make the edges softer or harder.

One attachment, which has been largely overlooked since hot lights went out of style, is barndoors. Barndoors are panels mounted on a frame in front of a light that can be moved into place to block light from certain areas. They are still available, but the selection your strobe manufacturer carries may be limited. All barndoor sets have four blades; two horizontal and two vertical. The best sets split each blade into two or three panels, making adjustments much more versatile. Should you buy (at least) one set, see if you can get a set that features split blades. By varying the angle of the light and the width of the blades, you can achieve some beautiful results (images 7.52–7.54, facing page).

For those of you with adventurous souls and minimal dollars, take a trip to your local hardware store and check out their selection of HVAC duct work. Specifically, look for aluminum floor or wall "register boxes." These are the pieces that mount behind heating or AC registers in homes or of-

fices. They are pre-formed to some interesting shapes, and I've found some that fit right inside my parabolic reflectors.

I'll often set a light with a parabolic on a nail plate, aim it straight up to the ceiling and set one of the right-angle ducts right into the reflector. When the business end of the duct is aimed at the wall, the result is a background light with its own personality, unlike any other modifier in the studio. The best part? They currently cost less than ten bucks! See images 7.55–7.57.

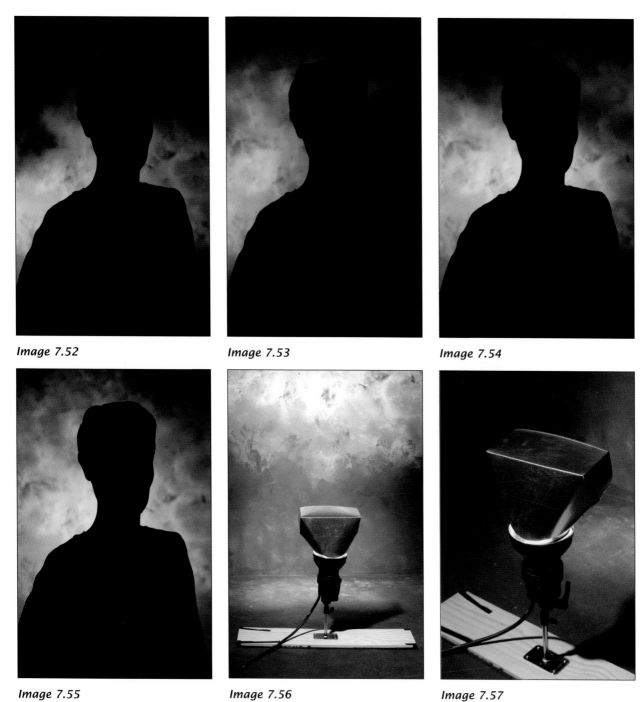

Image 7.52

Image 7.53

Image 7.54

Image 7.55

Image 7.56

Image 7.57

8. *Hair Light Options*

Now that we've taken a look at a number of options for background lights, let's apply some of the same principles and modifiers to another position, one that's frequently undervalued in portrait photography: the hair light.

In classical portraiture, hair lights serve two purposes: they provide an accent to the shadow side of a subject's face, adding dimension to it, and act as a "kicker" to visually seperate the subject from the background. Hair lights can be strong or subtle, as their look depends on the modifier used and, of course, your own taste as image creator.

Obviously, I'm somewhat limited as to how much space this chapter can occupy, and it's impossible to shoot samples that would cover every modifier possibility. That's where you come in. Don't just take my word for it, try your modifiers on the subjects that you photograph. You may find that a modifier I'm not particularly fond of will do a fabulous job for you.

Parabolic Reflectors

When you buy studio strobes you usually get standard, 6 or 7-inch diameter parabolic reflectors as part of the package. Often called "bowls" or "dishes," they are designed to take the light generated from the flash and throw it at the subject in the most even and efficient manner possible. The light coming from these reflectors will be strong and concentrated, a small source throwing hard shadows, without subtlety.

I chose a blond model for my subject because it's easy to overexpose blond hair. In all but one of the examples, I powered my hair light to the same f-stop as my main light. Some people have hair that's so dark and matte that it actually absorbs light, which means you'll have to power up the hair light for its effects to be visible. If you need to do that, be careful that you don't blow out the highlights on the neck, shoulders, or light clothing.

I set my hair light, fitted with a basic parabolic reflector, at a height of about eight feet, behind the subject and at camera left, aiming it at my subject's right (camera left) side. Even with the strobe powered to the same

Hair lights can be strong or subtle, as their look depends on the modifier used.

Image 8.1

Image 8.2

Image 8.3

Image 8.4

Image 8.5

f-stop as the main light, the light is so strong that it overpowers its own job, which is to be an accent light and not call attention to itself (image 8.1).

Now, you could power the light down to ⅓ or ⅔ stop less than the main light and give the light a subtler appearance (though it will still look "strong"). You may also need to use a lens with a focal length long enough so that the unmodified light does not fall on the lens, creating flare (image 8.2).

You may be thinking that you can just move the light more to the right and keep spill off the lens. You can do that, but if your subject turns her head too far, the light may show on the side of her face or, worse, on the side of her nose—definitely not flattering, even though my model is quite lovely when looking at the camera (image 8.3).

Beauty Bowls

How about a beauty bowl? A beauty bowl (also called a beauty dish) is an oversized reflector, generally at least 18 inches in diameter, with a device in the center that covers the end of the strobe tube, preventing any light from shooting straight out. Flatter than a parabolic, its light is both contrasty and soft, making it a great main light. A beauty bowl will send light flying in all directions, so it's best to fit it with a grid before using it as a hair light. Its size, and market demand, limits the number of grid widths available, with most manufacturers offering only 20 or 25 degree grids (images 8.4 and 8.5).

Image 8.6 and Image 8.7 (left pair). *Image 8.8 and Image 8.9* (right pair).

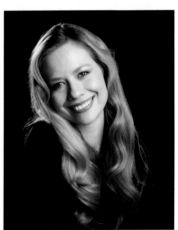

Image 8.10 and Image 8.11 (left pair). *Image 8.12 and Image 8.13* (right pair).

Grids

Add a grid (also called a honeycomb grid) to the strobe's parabolic reflector and the quality of the light changes and begins to take on character.

I have two sets of grids in my studio, in 40, 30, 20, and 10 degree widths. I also have a 5 degree grid for those times when I need to throw a very small spot of light. I've often wished I had one more set, but I'm able to move what I have in or out of the set and control each of my lights independently. Whether you use monolights or pack-powered strobes, you can do the same thing as long as your lights adjust asymmetrically.

Beginning with the 40 degree grids, here's what you can expect to see if you have the same range of grids. Notice that the intensity of the light is about equal, shot to shot, but that the spread of the spot narrows with each succeeding diameter (images 8.6–8.13).

Grids are a relatively inexpensive way to modify your hair and background lights, but you can use many of your favorite main light modifiers as well.

Softboxes

Though I occasionally use parabolic reflectors for hair lights, I'm much more entranced by the quality of light I get with softboxes. Because a softbox is a larger, broader source than a parabolic, light from it will fall more gently onto the subject. Depending on its position to the subject, the light may illuminate a subject's entire side, from the top of the head to the elbow, without showing the parabolic's characteristic hot spot.

Note that using softboxes or other main light modifiers will present the same problems as when using parabolics, and the light must be kept from flaring onto the lens or intruding too far into the frame. Depending on your studio space, it may be necessary to control them even more tightly, perhaps even using gobos or flags to shield the lens.

My first sample was made with a 2x3-foot softbox, set opposite the main light and behind my subject to camera left, positioned so the strobe head was slightly higher than the top of her head. As you can see, this is beautiful light that covers the entire side of her head, even the top of her shoulder, without any harshness (images 8.14 and 8.15).

Because a softbox is a larger, broader source than a parabolic, light from it will fall more gently onto the subject.

Image 8.14

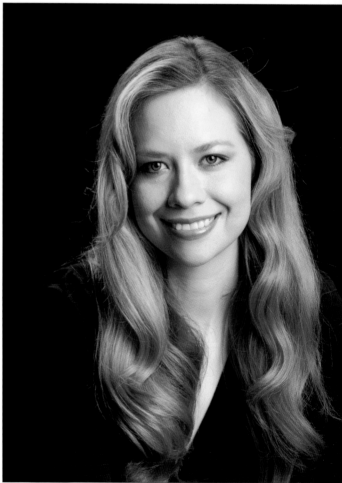

Image 8.15

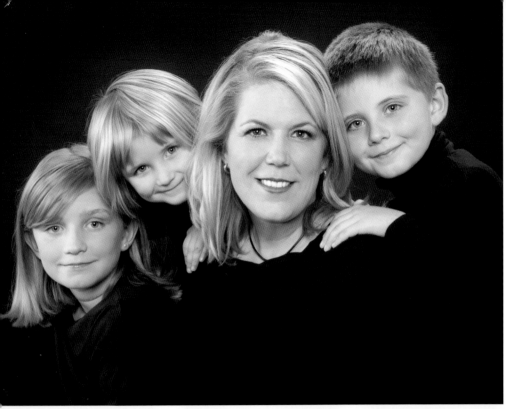

Image 8.16 (top). Image 8.17 and Image 8.18 (left pair). Image 8.19 and Image 8.20 (right pair).

Strip Lights. My current favorite hair light softbox is a 1x6-foot strip light. I've found it to be an invaluable accessory, especially when lighting a group, as its length allows me to suspend it (via a boom arm) over all the heads, lighting each person evenly and equally. I have two such softboxes, so if I'm lighting a larger group, it's a simple matter to suspend the other one from the other side. If my clients all wear black, as I frequently request, this light's position separates them from a dark background very effectively (image 8.16). I will often suspend a strip light over a single person for the same reason, to separate all the edges from the background. Personally, I think this halo of light is very attractive, one more touch to make my images stand out from those of my competition (images 8.17, 8.18).

For a more dramatic effect, try increasing the power of the hair light to one full stop over the main light. You'll have to be careful when doing this because it's easy to overexpose bare skin or light clothing. You'll have to

pay attention to the angle of incidence, too, as light that bounces off the hair at an angle into the lens may look like overexposure. When you get it right, the result is very nice (images 8.19 and 8.20).

Umbrellas

You can even press the trusty old umbrella into play as a hair light, although umbrellas spray light more than any other accessory. You'll have to be careful to not let the light hit the camera or background. Light that hits the background from an umbrella, in my opinion, is rarely attractive.

I placed this umbrella on a boom arm over the subject to spill light onto both shoulders. It was also positioned relatively close, about three feet over the subject's head, to keep the spray of light away from the background and the camera (images 8.21 and 8.22).

Because an umbrella creates a broad source, made even more so by its close proximity to the subject's head, you'll have to pay attention to the angle of the subject's position. In other words, don't allow the subject to tilt her head so that the hair light falls on her forehead, cheeks, or nose. The two lights may be powered equally, but the addition of light in an area already lit will produce a very unattractive highlight (images 8.23 and 8.24).

Image 8.21 and Image 8.22

Image 8.23 and Image 8.24

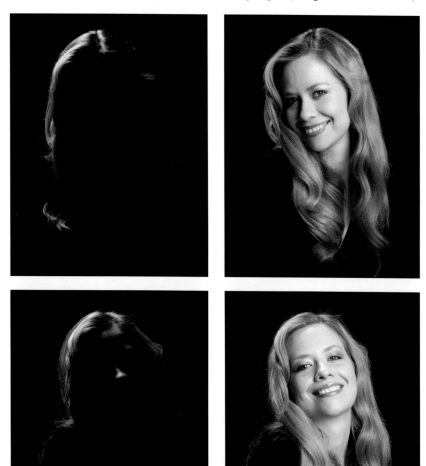

You can increase the glamour of the image just by doubling up on the hair lights. In other words, you can add an extra light on the other side (camera right, in this case) that's equal to the other. For the first set I used two lights, both fitted with 20 degree grids and placed at an equal height and distance from the model (images 8.25 and 8.26).

My final set used two strip lights, set on regular light stands and angled slightly, the top of each leaning toward the other. Both were set at an equal height and distance from the model and powered up to be one stop brighter than the main light (images 8.27 and 8.28).

Image 8.25 (left). Image 8.26 (right).

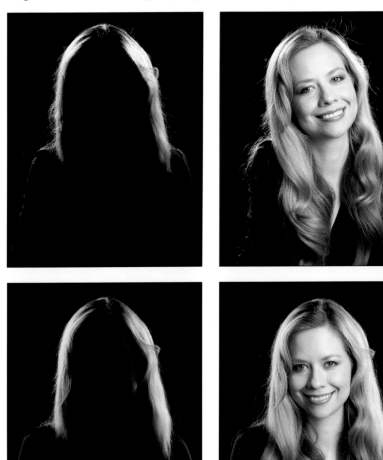

Image 8.27 (left). Image 8.28 (right).

9. Metering the Face and Profile

Perfect Exposure Begins with a Calibrated Light Meter

It doesn't matter if you use studio strobes, hot lights, or ambient light for lighting. If your images are consistently too light or too dark, it's probably not your fault; it's entirely possible that your light meter and your camera are not on the same page. I know that sounds improbable; after all, they are both precision instruments. But, while all manufacturers produce equipment to close tolerances, it's possible for a meter and camera to both pass their respective quality control tests but not be in agreement with each other. Fortunately, it's really easy to discover if the two machines are out of sync, and it's also easy to fix the problem.

You will need a neutral gray or white target. You can find collapsible targets from BalanceSmarter.com and Lastolite.com, both of which are gray on one side, white on the other. The BalanceSmarter product has printed lines on both sides to make it easier for your camera's auto focus to lock onto it. These products are invaluable for custom white balance as well and are available in several sizes.

For this exercise we'll use a gray surface, which will allow us to use the camera's histogram to judge the accuracy of the meter.

Begin by mounting the gray target on a light stand and aiming a strobe at it. You will get a more even light by setting the strobe at least 7 feet away from the target and using a softbox or umbrella to spread the light even more. Check the exposure with the light meter and move the target slightly forward or back, if necessary, until the exposure is a perfect whole f-stop, like f/8 or f/11, or a perfect third of a stop (f/+.03 or f/+.07). Check the top and bottom and both sides of the target as well, to make sure the exposure is even across the surface, no more than $\frac{1}{10}$ stop off in either direction (image 9.1).

Image 9.1

Fill the frame with the target (you can turn off auto focus if you can't get close enough with your lens) and take a picture. I try to just shoot the center portion of the target, to minimize any uneven lighting. Be sure your shadow does not fall on the target. Also, be sure to set the ISO on the meter to the same value as the camera. If your meter and camera are speak-

Image 9.6

Image 9.7

Image 9.8

this is absolutely true. The meter angle stays the same, straight on to the camera, but you begin to see some changes in the specularity of the light because it's now aimed at different planes on the face and reflecting directly into the camera from them (image 9.6).

At 45 degrees, the shadows deepen because there is no fill on the shadow side. The exposure, measured with the meter still aimed at the camera, still produced a perfect exposure when the strobe generator was adjusted to the target exposure, f/10 for this example (image 9.7).

At 60 degrees, which is farther than most attractive portraits will tolerate, a reading taken with the meter aimed at the camera still yields a beautiful result. Shadows and highlights are properly represented, even though the image is very contrasty (image 9.8).

So, what happens if we aim the meter at the light? At 60 degrees, what can the difference be, after all? Interestingly, the difference can be quite major. When you aim the meter at the light you will only measure the brightest part of the light, not the average of highlights and shadows we've been measuring so far. With the meter aimed at the light, note the difference in shadow density and highlight brilliance between the previous examples. The inference is clear: most circumstances do not require the meter to be aimed at the light. Aiming it at the camera will produce more consistent results almost all the time (image 9.9, facing page).

The easiest way to add fill light to your image is to bring in a white bookend (or any other kind of white fill) to add light to the shadow side. I've never been a fan of adding another strobe as fill; I much prefer a fill card of some kind because it will not add any shadows of its own. Be ad-

The easiest way to add fill light to your image is to bring in a white bookend.

Image 9.9 **Image 9.10**

When metering the hair light, place the meter close to the subject and aim the dome at the light.

vised that, even at 3 feet away from the subject, the extra light that bounces in will affect the overall exposure. In this case, using the bookend added ⅓ stop of light to the overall exposure, which meant I had to either take the exposure down at the source (as I would recommend) or move the main light straight back a few inches. This image, metered with the dome aimed at the camera, is a perfect example of how bounce fill can open shadows without looking at all like a second source of light (image 9.10).

When metering the hair light, place the meter close to the subject and aim the dome at the light. If you're using a gridspot, be sure to meter the light at the part of the body the camera can see, not the center of the grid unless it's aimed at that part of the body.

To meter the background light, first look through the camera and determine where in the background you want the light to equal whatever your target f-stop is. You can also just stick your head in front of the lens and take a look. Draw a bead on that part of the background, walk up to it, and place the meter flat against the backdrop. Take the reading and adjust the power or position as necessary.

Metering a profile is different in that it's one of the few times you'll need to aim the meter at the light rather than the camera. This assumes that the light is coming from in front of the profile (and from the side, relative to the camera). When the light is coming from any direction less than the 60 degrees we previously discussed you can meter, with confidence, with the dome facing the camera.

With the light coming from 90 degrees to the side, if we were to measure its strength with the meter aimed at the camera, the amount of shadow

would throw off the accuracy of the reading, causing a poor exposure (images 9.11 and 9.12).

Once you're satisfied with the reading and f-stop, set and meter any other lights you wish to use. I added a hair light and a background light, both powered to the same f-stop as the main light, and brought in a white bookend to open the shadows on her back and hair (image 9.13).

Of course, there are always options at your disposal. For a dramatic variation, I removed the bookend fill card, significantly deepening the shadows, then asked my model to turn her head to a ¾ position. The result? Beautiful, if I do say so myself (image 9.14).

 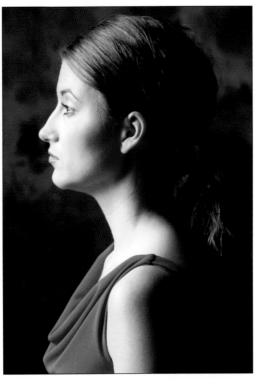

Image 9.11 (left). Image 9.12 (right).

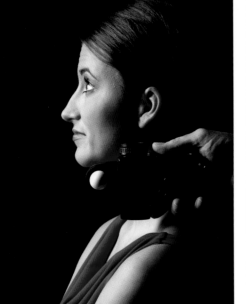

Image 9.13 (left). Image 9.14 (right).

10. Lighting, Up Close and Personal

When setting the main light, the first thing many photographers will do is place it fairly close to the camera. There's nothing wrong with that, of course, as it works just fine, looks great, and is at a comfortable, noninvasive distance from the subject. But what happens if we place a large

softbox main light much closer to the subject, less than 3 feet, in fact? How we can utilize that pesky Inverse Square Law to get beautiful images with a unique look?

Image 10.1

As I've already said, the Inverse Square Law states that light that travels twice as far from point B to point C as it did from point A to point B will be ¼ as strong at point C as it was at point B. Still with me? This means that if point A is 10 feet from the source and gives a light meter reading of f/16, the meter reading at 20 feet from the source will be f/8. In practical terms, the law means that light will lose its strength faster (fall off), as measured by a light meter, the closer one gets to the source.

My first setup placed my model about 2.5 feet from the background, with a large (4x6-foot) softbox also about 2.5 feet to camera left. Without any other fill, you can readily see how rapidly the light loses strength over the planes of her face. The light also falls off as it crosses the background but does so less rapidly because the background is twice as far from the light (image 10.1).

How we can utilize that pesky Inverse Square Law to get beautiful images with a unique look?

You may look at this image and ask yourself why you'd want a portrait with so much drama. The answer is that many clients will want such a look if they know they can get it. I shoot a lot of editorial and advertising portraits of professional people, from attorneys to radio and television personalities, and many of them love this look just because it is so strong. Even some of my seniors think this is cool because it's different from what the vast majority of grad shooters produce.

But, if you want to open the shadows, it's easy to just move a white bookend (or other bounce panel) into place, about two feet from the model. This simple modifier will bounce enough light back onto the face so that you'll need to remeter and tweak the main light to get a perfect third or whole stop. You can see this in the background, which now photographs a little darker because the bookend added ⅓ stop to her face but not the background (the amount of additional exposure value varies by the distance of the fill to the subject, so you'll need to move the bookend until you get it right). See image 10.2.

As a further example of light falloff, I doubled the distance between the model and the background but kept the softbox 2.5 feet from her. The light on the background is now only 25 percent of its previous strength, enough to hold detail in a lab print but dark enough to add drama.

This is beautiful light! It doesn't look at all like most portrait lighting, yet it shows great contouring, color contrast, and skin texture. Best of all, it was accomplished with only one softbox and one reflector. Yes, a medium (3x4- or 3x5-foot) softbox would work almost as well, though the shadows would be slightly more defined (image 10.3).

I know if you play with a light, a tape measure, and your light meter for just a while, you'll completely understand the concept of the Inverse Square Law and how to make it work for you. It's worth the playtime to get results like these.

If you play with a light, a tape measure, and your light meter for a while, you'll completely understand the concept.

Image 10.2 (left). Image 10.3 (right).

11. Feathering Light

A little more planning on the front end would mean no work at all on the back end.

Some time ago, I was involved in a conversation between photographers who believed that digital cameras simply could not record an adequate contrast range. Horror stories flew about the difficulties of shooting black-suited executives with white shirts, tuxedoed groomsmen and white-gowned brides, and interracial couples. The problem, as they saw it, was that one side of the contrast range had to be slighted in favor of the other. The ultimate dilemma, of course, was deciding which side would take the hit. Most decided it would be best to shoot for the bright side and fix the rest in Photoshop.

Though that approach works in theory, it's misguided in reality by assuming that exposure deficiencies can always be adjusted to "normal" by using Levels or Curves adjustments. They cannot. After a certain point ($\frac{1}{3}$ stop of overexposure or $\frac{2}{3}$ stop of underexposure), straight Photoshop adjustments will not look the same as a perfectly exposed counterpart. The second flaw in the argument is the tremendous amount of extra work a photographer would have to do just to make the proofs presentable. In other words, one would have to do major, time-consuming retouching on each and every image before making a single dime on prints. Such an investment of time is simply not acceptable in a successful digital workflow environment, even if you go through the trouble of shooting RAW files.

In truth, a little more planning on the front end would mean no work at all on the back end—no masking, no adjustments, no RAW processing—just a quick trip to the printer for terrific proofs (cosmetic retouching optional). We can accomplish this task in the studio by controlling the strength and direction of the light.

The models for this chapter are friends of mine, Sandra and Keith, who are very much in love and engaged to be married. He is African American, she is Latina. To make this exercise more difficult (and to prove how easy this actually is), I requested that Keith wear white clothing and Sandra wear black. Because I want substantial modeling of the planes of their faces, I will use only one light for my main light, plus two kickers and a background light.

A Bonus

As we were wrapping up this shoot, it occurred to me that this scenario would be very romantic without the main light. I turned it off but maintained the camera's aperture at f/5.6. The background light does wonderful things, adding a sense of mystery to the image, while the side lights contour my friends and give them some dimension (image 11.8).

The ability of light to feather itself across a large area is something that you'll be able to use in dozens of situations. You only need to play with this once to get the concept, and each additional time you use it, it will become easier to estimate just how much angle you'll need. The first time I tried it, years ago, I spent ten minutes getting it right. These days, it takes only a minute or two. The best part? You can feather light from much shorter light-to-subject distances.

Image 11.8

Breaking the Rules for Fun and Profit

An open mind on your end can equal an open checkbook on your client's.

We know that the exposure tolerance of digital photography, when shooting in JPEG, is roughly that of professional color slide film. The question posed in this chapter is whether or not we can use that short latitude to produce overexposed (in some tones) yet evocative images.

Perfect exposure is only a rule if you want it to be. In truth, the use of overexposure is an underrated tool. Given the relative ease with which custom labs could produce a nice print from an overexposed negative, many photographers thought of film overexposure as merely a nuisance. Today, with the digital JPEG tolerance carved in Jello (it could change tomorrow), at $+\frac{1}{3}$ stop, and "perfect" prints at exposures greater than that pretty much impossible, the question of how to use the tool begs to be investigated.

An open mind on your end can equal an open checkbook on your client's.

I was shooting a model's portfolio when I thought it would be interesting to exploit the tendency of light to expand in all directions as it leaves its source, and to see what it would take, in terms of overexposure, to get the light to wrap around the subject. To do so, I set a large, 4x6-foot softbox about a foot behind the subject. There were no fill cards, bookends, or reflectors used in this set to bounce any light back to the model. I expected lens flare (actually, I was counting on it), but minimized the potential adverse effects by making sure that my lens and UV filter were cleaned and spotless. I aimed my flash meter at the background from her shoulder, adjusting the variator until I got a perfect f/18. I chose such a high power because I knew the possibility for silhouettes would dominate the series, and I wanted a spread of large aperture, overexposed images, like an extended bracket.

I was thrilled as I watched what was happening, using the camera's LCD as a guide (which is all it's really good for). As the exposures increased in power, the light, as expected, wrapped itself around my model. With each exposure change the color contrast decreased while the soft mood of the light increased.

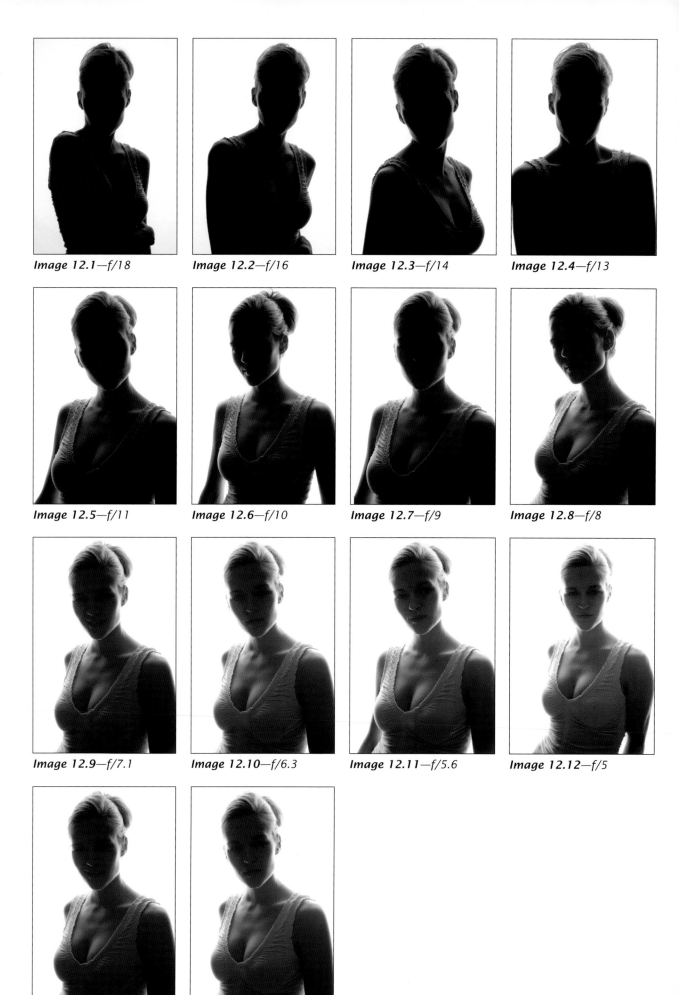

Image 12.1—f/18

Image 12.2—f/16

Image 12.3—f/14

Image 12.4—f/13

Image 12.5—f/11

Image 12.6—f/10

Image 12.7—f/9

Image 12.8—f/8

Image 12.9—f/7.1

Image 12.10—f/6.3

Image 12.11—f/5.6

Image 12.12—f/5

Image 12.13—f/4.5

Image 12.14—f/4

Image 12.15 (right).

The first set, shot in increasing increments of ⅓ stop (and without any Photoshop intervention), is shown on the facing page (images 12.1–12.14).

After a quick, side-by-side image check on the monitor, I decided to use f/4.5 for the finals. The model changed wardrobe and we began. After a few minutes of shooting and downloading, this image emerged as a favorite (image 12.15).

As nice and different as it is, I felt it could use a little more zip. I didn't want to set up more lights (I was officially intrigued with the one-light softbox scenario), so I moved in a 4x8-foot white foamcore bookend at camera-left, angled about 45 degrees off the lens axis. As you might expect, the "usable" images now start earlier in the series since we're relying on a bounce of light rather than a wrap, which is stronger. Depending on the mood we wish to impart,

Image 12.16

we now have more choices, even though the look of each image is slightly different.

As I reran the series, beginning once again with f/18, the effect of the bookend became immediately apparent. You can easily do this yourself, so, for the sake of this book's page count, I'll present just the last four images, beginning with f/5.6 after the diagram (images 12.16–12.20).

Image 12.17—f/5.6

Image 12.18—f/5

Image 12.19—f/4.5

Image 12.20—f/4

After checking the tests, the model and I decided we liked the look at f/5 the best, and the final selection looks great (image 12.21).

Modifying the Basic Setup

I like to think that if I've put a fair amount of time and trouble into any given lighting scenario, then there are other options available to me while using the same basic lighting. This way of thinking has saved my bacon a number of times on location shoots, when there's no time to relight and just a little time to reposition the subject. Editors and art directors really appreciate more than one approach to a subject (which often saves *their* bacon, something very dear to them).

Moving the camera about 45 degrees to the left puts the light on the camera-left side of my subject and increases the zone of overexposure tremendously. I liked the potential of this, so I moved a black bookend

Image 12.22

Image 12.23

Image 12.24

behind the model, angling it so the softbox would not shine directly onto it, diluting the bookend's ability to absorb light. An additional white bookend was placed to the new camera right, to bounce a little light back onto the subject's shoulder and separate her from the background (image 12.22, diagram).

After I metered the light that fell on her shoulder, a quick test indicated that an aperture of 2 stops above that reading would give me a spectacular result, different from anything else I'd done that session. This image incorporates the softbox, on the left, both as a compositional element and to indicate how close to my model it actually was (image 12.23).

Shortly after shooting the images for this chapter, I had the opportunity to photograph a three-year-old in her favorite persona, that of prima ballerina, for her parents. Thinking it would be fun to put my softbox/overexposure theme to work, in addition to the other images I intended to shoot, I built a quick set by simply placing a piece of plywood on sawhorses, high enough, of course, for the softbox to be centered behind my little diva.

There's something about little girls and costumes that's just too good to pass up. Once she thought of me as her "director," she gave me a great performance, nothing less than her very best. This is my favorite image from that set, made without any additional fill or bookends (image 12.24).

Overexposure is a wonderful yet somewhat unpredictable tool, one more that I suggest you play with and understand. It's beautiful in its own way, and unlike any other lighting scenario.

As professional photographers, we should always be looking for ways to set our images apart from those made by our competition. For those of us who may shoot strictly for personal pleasure, every opportunity to grow as a visual artist should be explored.

Now, I understand that many photographers are limited to one or perhaps two lenses. They are expensive—especially the good ones—and the decision to purchase another piece of high-priced glass should never be made lightly. Still, if you can make a quantum leap in the quality of your work by buying another lens, well, I would strongly recommend that you do so.

As I was learning my craft, I heard and read about a number of rules regarding the correct focal length for portraiture. For 35mm, most people seemed to agree that a focal length that was roughly double that of a "normal" lens would do the best job, and that meant a lens of 100mm. A medium format camera, such as a Hasselblad, required a 150mm lens to qualify as "perfect." Personally, I think such rules are hooey, and I'll use whatever I think is best for the job.

A problem that I see with using lenses of short focal length is the lens's inability to soften the background enough to make it unobtrusive. When the background is soft, the subject will stand out and the image will look more dimensional. Moving your subject far enough away from the background is sometimes possible when working outdoors, although you do run the risk of picking up unwanted details, like cars or telephone poles, which tend to look bad whether they're in focus or not.

In the studio, the problem is compounded when using strobes. Many photographers buy strobes with sufficient power to light a group portrait from a considerable distance, even when using a softbox or umbrella. Generally speaking, these strobes will not power down low enough to use a large aperture for minimal depth of field.

Let's begin by making a portrait at 70mm. I chose that focal length because many folks have only a 24–70mm lens, or roughly the equivalent. Though you can certainly shoot successful portraits using shorter focal

When the background is soft, the subject will stand out, and the image will look more dimensional.

Image 14.1 (top left). Image 14.2 (top right). Image 14.3 (bottom).

lengths, using the maximum will shorten perspective as much as that lens will allow and correspondingly soften the background.

When you shorten perspective, you also narrow the angle of view. My subjects are typically placed about eight feet from the background. At 70mm, even for a head and shoulders portrait, I'll have a fair amount of real estate behind the subject that I'll need to light perfectly. My main light, hair light (at camera right), and background light were powered to the same f-stop, f/13. The accent light at camera left was powered ⅓ stop brighter. You see that, even with the model 8 feet from the background, there's sufficient depth of field to deliver a fair amount of sharpness to the wall (image 14.1).

At 135mm, which is a standard prime lens focal length, the background begins to soften, though focus is crisp over her entire figure. You can see how the angle of view has narrowed even more, with the background looking more evenly lit than in the previous image because there is less of it to light (image 14.2).

At 200mm, the background softens further, the angle of view is even narrower, and focus falls off noticeably, beginning near her ears but becoming unmistakably soft in the hair at the back of her head (image 14.3).

Though I'm usually pleased with this result, I sometimes want even more softness in the background and even less depth of field on my model. You may want the same, and here are four options for you, depending on your equipment:

When you shorten perspective, you also narrow the angle of view.

1. Power down your lights (or just start at low power). If your gear allows you to symmetrically power down, so much the better; otherwise, you'll have to meter each light. I'd recommend you do a new custom white balance when you're done, as many strobes will show a noticeable color shift at low power.

2. Buy several sheets of Rosco (www.rosco.com) neutral density gel. Rosco makes neutral density material in a number of strengths, so test your equipment to see how powerful it is, then buy the appropriate gel (if the lowest your strobes will go is f/8 at your favorite working distance, then a –3-stop sheet will get you to f/2.8). Either tape a piece of gel over your reflectors or wrap it over the tubes, inside a softbox. Be careful not to let it touch the tube. It's tough stuff, and it will take quite a bit of heat, but it can melt if it's touching the bulb and the bulb gets hot enough. Be sure to do a new custom white balance, as the material may not be completely neutral.

3. Buy neutral density (ND) filters for your lenses. Choose filters that are at least the diameter of your largest lens (even larger is better, as you'll avoid vignetting problems if you stack more than one), then use step-up or step-down rings for your other lenses. You'll avoid having to duplicate your ND filters, and they can be pricey (image 14.4).

Image 14.4 (top left). Image 14.5 (top right). Image 14.6 (bottom).

4. Most portraits don't need to be super-duper razor sharp, if for no other reason than to spare your subjects the realities of time. Instead of buying gel for every light, buy a couple of sheets of different densities and tape a small square over the lens. Keep it as flat as possible. Be very careful not to fingerprint the surface and to flag any light that falls on the lens. Be sure to custom white balance, too, as you will almost certainly get a color shift. The images will be more than adequately sharp, and you'll get beautiful, soft backgrounds with minimal depth of field. I used a piece of –3-stop material for this image to get f/4.5 with a 200mm zoom (image 14.5, facing page).

Image 14.7—The light for this image was powered to f/8 but was effectively changed to f/2.8 by attaching a 3-stop neutral density filter to the lens. In situations with such short focus, be sure to focus on the eye nearest the camera.

I used three lights to create image 14.5—a medium softbox for the main light, a beauty bowl fitted with a 25 degree grid for the subject's hair, and a 1x6-foot strip light softbox for the extra highlight on her neck. The strip light threw enough light to illuminate the background but was blocked from the camera with a black bookend (image 14.6, diagram).

The things we do for our art.

I had a number of sets ready for my shoot with this beautiful woman (image 14.7) and didn't have the room to set up a flat surface on sawhorses to get her off the floor and into a more comfortable position. I wasn't that concerned about her comfort (she'd be lying down either way), but I was concerned about mine. She was on the floor, so I had to be there, too, and I had to crank my neck to get to the viewfinder while lifting a 70–200mm f/2.8 zoom lens to the proper position as I directed her through a number of frames.

I felt like Quasimodo the next day. Who says photography's not dangerous?

15. The Bookend Bounce

Bookends are perhaps the most valuable and inexpensive accessory that you can have in the studio. They are comprised of nothing more than two 4x8-foot sheets of white foamcore, butted together and taped to create a vertical seam. They can be used to bounce light like a reflector or to block it like a gobo, and they weigh almost nothing. Foamcore is also available in black, so you can make white/white, black/black, or black/white bookends. Here's a way to use a bookend that will give your images a truly unique look.

We know that the contrast of light decreases as the size of the source increases. For some situations, this means that a large softbox set close and relatively straight on to the subject will produce light that appears flat, without life. But what if we could produce a very broad light source with significant color contrast? We'd have the best of both worlds; a broad source that would let the subject move around without odd shadows and a source with "punch." I reasoned that a strobe with a 6-inch parabolic reflector, aimed into the bookend from behind, would produce a relatively even light with a wide hot spot that would bounce back to boost color contrast.

Image 15.1

To get an idea of what this would look like, I opened the bookend to a wide angle, placing it about twelve feet from the background. I then set a light on a boom arm about four feet from the background, about nine feet off the floor, and aimed it into the bookend. I positioned myself about two feet away from the bookend, looking into it. Using a hand mirror to see its effect on me I realized that using the bookend "as is," while bouncing back beautiful light, would render eyes with minimal color in the iris because of the overall white reflection. Images with eyes as lifeless and glassy as what I was seeing would be useless and unsaleable.

The solution was simple and inexpensive. A quick trip to the hardware store garnered a small can of matte black spray paint. After cutting a hole in the bookend, at camera height and at the seam, I applied streaks of black spray paint radiating outward from the center of the hole to absorb light that would otherwise reflect back at my subject's eyes (image 15.1).

Image 15.2 (left). Image 15.3 (right).

The wraparound light lit both sides of each iris, adding color and life in a very interesting way.

As I looked through the hole in the bookend, toward where my model would be standing, I realized that the bright light from the parabolic reflector, centered over the model's mark, would flare into my lens. A small piece of black board, clamped to another boom a few feet in front of the strobe, cast a shadow over the opening. Problem solved.

While waiting for the model, I performed a custom white balance on the light that bounced off the bookend in order to neutralize any unwanted color from the foamcore.

When my model was ready, I positioned her 2 feet from the opening to take advantage of the wraparound light. The strobe itself was aimed directly at the hole but allowed to fall on her head and shoulders.

Needless to say, I was very impressed with the quality of this light. Not only was my model, Christine, beautifully represented, but the highlights—a full 2 stops brighter than the bounce—framed her in a very glamorous way (image 15.2).

Most exciting was how the bookend bounce lit her eyes. The wraparound light lit both sides of each iris, adding color and life in a very interesting way. The black spray paint added depth to her pupils and actually made her gaze more intense because it made her pupils appear smaller (image 15.3).

To make this scenario even more intense, I replaced the small black flag with a 12x12-inch mirror tile that I'd taped to a clamp and attached to the swivel post on the boom, aiming the light that would have fallen onto the opening back toward the background but maintaining the shadow over the hole. The mirror threw a beautiful soft-edged reflection of itself onto the background (image 15.4, page 82).

Image 15.4 (left). Image 15.5 (top right). Image 15.6 (bottom right).

One thing that had bothered me just a little about the first set was the bright highlight on the subject's chest. I simply had her turn the other way to fix the problem. The final images, with the +2 stop highlights and the +1 stop reflection are, indeed, unique (image 15.5).

This is one of the coolest tricks I've ever thought up, and you'll see several more examples of it in later chapters. If you try this yourself, and I certainly hope you do, use this diagram as your point of departure (image 15.6, diagram).

16. Perfect White Backgrounds, Perfect High Key

For sheer beauty, it's hard to argue against a perfectly white bacKground.

For sheer beauty, it's hard to argue against a pure white background, but if you use paper or cloth, perfection may be difficult to achieve, as lighting for either is tough to control across the entire surface of the background. It can be done, of course, but often requires more lights than are available, more space than is free, or more time than you have.

One of my favorite solutions is to hang a 4x8-foot sheet of ⅛-inch milky white Plexiglas (or similar acrylic plastic) between two light stands and lighting through it from behind with a large, 4x6-foot softbox. One could also use a smaller softbox, especially if the area to be lit is smaller, like a head and shoulders portrait, because the light will tend to fall off a bit on all sides. I've found that placing the diffusion panel of the softbox about three feet behind the Plexiglas is perfect for most everything I shoot with it (image 16.1 [diagram], page 84). In my corner of the world, current cost for a ⅛-inch, 4x8-foot sheet is around $70.00.

Note: When you try to clamp the Plexi to its support, it might give you a little trouble; the ⅛-inch thick material will tend to bow and fall over on itself. It's actually the easiest size to work with, though. Just be a little careful, and you'll get the hang of it in no time. A ¼-inch material is also made, but it's too heavy to lift easily and will absorb too much light.

Even with the extra diffusion the panel will provide, there will be a hot spot. The trick is to find the correct exposure to make the background uniformly white. If I'm doing a portrait, I like to set the strobe head about even with the height of my subject's head. This will guarantee the largest part of the hot spot will be evenly distributed around my subject. I know the term "hot spot" conjures up troubled thoughts of overexposure and lens flare, but that's not the case here. The Plexi is so evenly diffused that a true hot spot is very unlikely.

You'll want to know the strength of the light coming through the material, and the easiest way to do this is to retract the dome of the meter and press the flat surface against the Plexi (because it's also a flat surface). If you cannot retract the dome of your meter, you may need to make a few tests to determine how the extended dome influences the exposure value.

If you make a photograph of the Plexiglas according to what the meter says, you'll get a light-gray background. The meter's job, after all, is to give you the numbers to produce an image with adequate detail. It's not until the exposure at the camera is increased by a full stop over what the meter measured that the background becomes an overall pure white.

Think about this for a minute: by understanding how the material carries light and how the interpretation of the light meter reading influences the final result, you will have another creative control at your fingertips. Whether you want a pure white or light-gray background (or a combination of the two), you can create it quickly and easily anytime you wish.

Because Plexiglas is a thick diffusion material, it's perfect for softly lit, partial silhouettes. Light is pushed through it evenly and in all directions, making it wrap around the subject in varying degrees of soft-

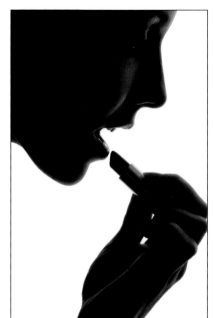

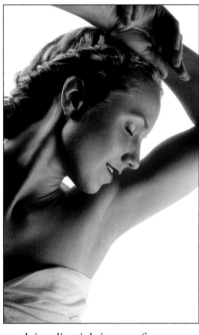

Image 16.1 (top left). Image 16.2 (top right). Image 16.3 (bottom left). Image 16.4 (bottom right).

ness. This shot of my friend, Margot, applying lipstick is a perfect example. She's lit only by the background light and without any fill except what's bouncing around the studio. The aperture was set at one stop more than what the meter read from the background. This is a perfect shot for a model's portfolio, but just imagine what this light would look like on a bride with her flowers, or a couple in love as they're about to kiss (image 16.2).

No matter what secondary lights are used, this background is so clean that everything looks terrific. In addition to the background light, I used two strip lights for this shot. Strip lights will throw soft, narrow beams of light that beautifully accent detail, like Margot's hair, without excessively dark shadows (image 16.3).

For this shot, the box at camera right was angled up, and the box at camera left was angled down. Both were powered to the same f-stop, one full stop under the background. Those are important details that may not be evident in the lighting diagram (image 16.4, diagram).

This is beautiful light for glamour photography. I used an 18-inch beauty bowl for the main light, positioned just above the camera to fully light Margot's face as she tilted her head toward it. The placement of the light meant her facial shadows would not be attractive if she looked directly at the camera but would be perfect when she was looking upward (image 16.5).

Remove the softbox and replace it with a strobe with a traditional parabolic reflector fitted with a grid. Aim it at the Plexi to throw a perfect circle behind your model, then fit the front light in the same manner. Properly done, it will look like the front light was the only light, because the gridspot circles will match and form a pattern. Unlike a traditional spotlight portrait, the rear light throws light back into the scene, as you can see on her arm, giving the shot more life and depth. In order to get that look with this image, the rear light was fitted with a 20 degree grid while the front reflector, which was farther away, held a 10 degree grid (image 16.6).

You can also achieve interesting results by adding a colored gel to the background light. To get the transition from purple to white, I left a very small portion of the reflector not covered by the gel (image 16.7).

Many photographers think high key lighting means overexposure. After all, the term "high key" was coined to refer to the brightness of the key, or main, light. Yet, if you think about it, it's a misnomer because a high (bright) key light must be properly exposed for the image to be, well, properly exposed. "High key" only means that the vast majority of tones in the image are above middle gray, and as high above middle gray as possible without sending it to the stratosphere or lending it an RGB value greater than 250, whichever comes first.

Image 16.5 (left). Image 16.6 (center). Image 16.7 (right).

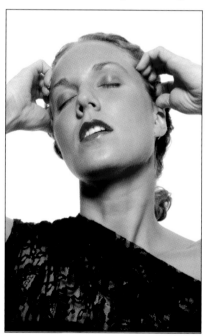
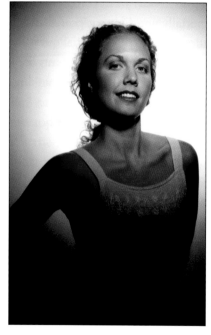
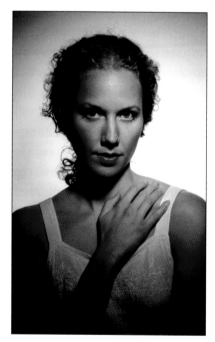

Image 6.14 (left). Image 16.15 (center). Image 16.16 (top right). Image 16.17 (bottom right).

a reflective floor with just the HiLite and the main light. That look almost always requires some work in Photoshop, but I wanted to minimize that as much as possible. Note that it would be possible to eliminate almost all Photoshop work if the model were placed on mirrored Plexi, but any reflection would be much stronger. I wanted a soft reflection that only hinted at a shiny surface.

The Plexi was also angled up to the surface of the HiLite to produce an unbroken reflection.

My final image is quite striking, the background is pure white, and the foreground is almost the same (image 16.14).

Getting rid of the residual foreground was extremely simple in Photoshop, taking about a minute from start to finish. Here's how it was done:

The Magic Wand tool was used to select all the white areas of the background and foreground. *Note:* If you need to select more than one area, simply hold down the Shift key while making the extra selections (image 16.15).

I then went to Select>Modify>Feather and entered a feather radius of 1 pixel to slightly soften the edge (image 16.16).

Next, I selected Levels. The spikes shown in the histogram represent the few pixels that were not pure white. I moved the highlight slider past the spikes to the flat line, then clicked OK (image 16.17).

The final image shows a totally white foreground and background with just a hint of reflection—exactly what I wanted (image 16.18).

Image 16.18

To many photographers, the term "low key" means underexposure. This assumption is inaccurate, though, because the main light (whichever light it might be) must be properly metered and the image properly exposed to look correct. Any other approach is just smoke and mirrors. Low key lighting is in fact achieved when the majority of tones in the image fall below middle gray (as evidenced in the image's histogram), but are not so dark that they won't carry detail.

Later in this chapter, we'll look at low key lighting in a series of portraits of a most interesting gentleman. Bill Foster is a former comedic radio performer, now a legal arbitrator/mediator with over 4,000 cases to his credit, and co-founder of a men's crisis center. Well dressed and well spoken, he's also fond of fine cigars. I wanted to create a portrait that would meld his humorous persona with the drama of his profession, and low key was the way to go.

For Bill's portraits, I'd envisioned a light that would be narrow and long, like a strip light but softer, like light from a much bigger softbox. The narrow part would throw a crisp and relatively defined light with a punchy, but not overly dark shadow. The wider, softer portion of the light would wrap around the subject, softly illuminating detail and filling in most of the shadows. Well, such a modifier doesn't exist commercially (to my knowledge, anyway), but it was an easy thing to create using a pair of bookends. (In my books and workshops, I've often praised the merits of the simple bookend as a light modifier. When black foamcore is used instead of white, bookends can also be used to create "subtractive" light, wherein incidental or bounced light is kept off the subject. Bookends are my favorite light modifiers, and I use them in one form or another in almost every portrait I shoot.)

To begin, I placed a bare-tubed strobe on a stand, then positioned the unit inside the triangle formed by two bookends butted together to form a triangle. The strobe head was set quite high, about seven feet above the floor, and aimed down into the back wall of the triangle and down, to bounce light toward the subject.

When black foamcore is used, bookends can also be used to create "subtractive" light.

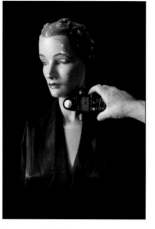

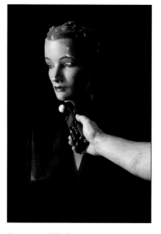

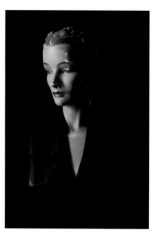

Image 17.1 Image 17.2 Image 17.3 Image 17.4

To narrow the light, I closed the two open ends to allow a vertical opening roughly four inches wide. Remember that light wants to expand in all directions as well as in a straight line. My thinking was that the strongest light would be on a straight line through the opening to my subject, and softer light would follow the angles of the bookends and spread around the subject (image 17.1, diagram).

I wanted to test the light before Bill got to the studio, so, with my main light in place, I moved my assistant, Madge, in from her office in the storeroom and onto the set. Madge can hold a pose for hours, an ability that allows me to show you a tip of great importance. This lighting scenario is one of the few times you may wish to deviate from the metering standard of aiming your meter's dome toward the camera. Why? The dome of the meter takes into account the highlights and shadows that fall across the face to give you a perfect representation of the specular highlights, the diffused highlight, and the transition zone as the light moves into shadow. In a case like this, when the meter is aimed at the camera, it reads a lot of shadow and wants to compensate, causing the face too appear brighter in the final image than you may want it (image 17.2).

In low key situations, you'll want the emphasis to be on the diffused highlight, the portion of the image that carries the most visual information. When the meter is pointed at the light, it allows us to creatively cheat, to increase the look of low key lighting without compromising the quality of the exposure. Aiming the meter directly at the main light guarantees a flatter response, a reading of only the strongest values, which allows the shadows to be more correctly represented (image 17.3).

The difference between the two meter readings, in this instance, is about 2/3 of a stop. If you make the two readings and think the shadows are too deep or the highlights too bright, simply split the difference. This "middle of the road" result is quite usable, as Madge so aptly demonstrates, and is a decision entirely up to you (image 17.4).

In low key situations such as this, you'll want the emphasis to be on the diffused highlight.

In situations where I use a hair light, I want it to dominate.

Personally, I don't think a hair light has much value in a low key portrait. I much prefer to use a background light to determine the shape of the shadow side of the subject. I also prefer to power the background light to be less than the main light because subtlety counts toward the mood of low key light.

To get an even touch of the light against the black paper sweep, I set a 2x3-foot softbox about two feet from the backdrop and aimed it, parallel to the paper, straight across to the other side. I also set a black bookend between the softbox and Madge to keep excess light from spilling onto her. The image sequence below shows the effect of diminishing exposure from normal (equal to the main light) to –1 full stop (images 17.5–17.8).

After reviewing the test images of Madge, I decided to meter the main light by aiming the dome directly at the light and to use a background light at –⅔ of the main light. I knew Bill would be wearing a black suit, but I wasn't worried about losing detail. When the exposure is correct, all is right with the world.

After a few position tests, Bill sparked up a smoke (I didn't mind—there was one for me, too) and we got to work. I noticed that his glasses had a nonreflective lens coating. Such a coating will still reflect the strongest highlights (though they will appear significantly subdued), and I exploited this quality by including the reflection of the main light in the lenses (image 17.9, page 92).

The first shots had Bill angled toward the main light, but this scenario is versatile enough to allow posing changes without changing the position of the main light. This image, which presents him straight to the camera, demonstrates the visual strength of the light (image 17.10, page 92).

Early in this chapter, I referred to the main light as "whichever light it might be." In situations where I use a hair light, I want it to dominate. In

Image 17.5

Image 17.6

Image 17.7

Image 17.8

this case, I added a third light, a strong hair light, from the same side as the main light. This is not usually done in traditional portraiture, but there's no rule against it, and the result can be very effective. Note that even with a grid, like the 20 degree grid I used here, the odds are you'll get lens flare because the light is so close to the lens's axis. Be sure to gobo it off with a black bookend to keep light off the camera (image 17.11, diagram).

After I set the hair light to skim over the side of Bill's face, I powered it up to ⅔ stop over what had been the main light and reset the camera to the new reading. Changing the camera's aperture to the power of the new light meant I had to increase the background light by ⅔ stop to keep the same look on the sweep. Decreasing the exposure on Bill's face by ⅔ stop increases the low key look, yet the key is properly exposed (image 17.12).

Low key light requires more planning and forethought than other lighting scenarios but is worth it in terms of drama and strength. Never allow the shadow areas to merge into black, especially around the head and shoulders, unless those areas are inconsequential. Do not—under any circumstances—use the camera's LCD as a light meter. The LCD is not capable of subtlety. If you want accuracy (and you'd better), use a flash meter.

Test this yourself. If you don't have a Madge in your employ, a beachball on a stool will work almost as well.

Image 17.9 (top left). Image 17.10 (top right). Image 17.11 (bottom left). Image 17.12 (bottom right).

18. Why Strip Lights Are So Cool

Image 18.1

I know I won't be telling you anything you don't know when I say that photographers are just little kids playing with their toys. Over the course of my career, I've been lucky to be interested in shooting everything, and I have managed to stock a very large toy box with all sorts of goodies.

Some time ago I decided to replace my nondigital studio strobes with new gear as sophisticated and precise as my camera and light meter. I wanted to duplicate everything I'd previously purchased and add a few new items as well. Though I've always had a wide selection of softboxes, I'd never before had a totally matched set. In the past, I added gear as necessary, or just because I wanted to play with something to see what it could do. There's nothing wrong with that approach—it's certainly less of a strain on the ol' checkbook than doing it all at once—but the various brands and ages of the equipment meant color temperature differences were getting wider as the gear got older and digital cameras got better.

Along with everything else, I replaced two earlier strip lights, about 16x48 inches each, with 1x6-foot Profoto strip light softboxes. I became so enthralled with the look and shape of the light they produce that I now use them in place of more traditional modifiers and in situations I'd never thought to try before. I think you'll see possibilities for your work, too.

When used as a background light, these long, narrow boxes create a long and consistent light that's reminiscent of a horizon just after sunset. In this shot of a singer, the strip light creates a background light that splashes and rides up the folds of the curtain just as bounce light from a spotlight might do (image 18.1).

Use two strip lights, one from each side, to illuminate both the subject and the background. When they're evenly spaced relative to the subject and the background, and powered to the same strength, the light is even across both. The look is terrific and very easy to create, yet it's important to remember that the model can't be too far forward of the background (about four feet, in this case). As the model is moved farther away from the background, it will become darker, because the light will lose strength (image 18.2 and 18.3 [diagram], page 94).

Image 18.2 (top left). Image 18.3 (bottom left). Image 18.4 (center). Image 18.5 (right).

For product and stock photography, softboxes like these have a lot to offer. For example, beverage, stemware, and cookware photographers spend a great deal of time placing highlights that accent the form of the product. Because strip lights are so long, they can create a highlight that runs the entire height of the vessel.

The highlights on this glass of brandy were easily formed by setting a softbox on each side, angled to a V shape to mimic the shape of the glass. Both strobe heads were powered equally. In order to get a reflection that followed the entire shape, it was necessary to place the bottom of the light below the base of the product (image 18.4).

This shot of old boots was lit by placing a strip light flat against the back of a sheet of milky white Plexiglas, so that the edges would stay relatively sharp and defined. The parabolic reflector on the main light was fitted with a 10 degree grid to keep light from spilling onto the Plexi and diluting the shadow (image 18.5).

You can use one of these modifiers to create beautiful hair light for an individual or multiple strip lights to create even, semicircular coverage over

your subjects' heads and shoulders. Center the light over and slightly behind the subject(s).

Gelling the light is as easy as taping the colored acetates to the black nylon frame of the softbox, a little trick that produces stunning results for applications such as editorial or stock photography. The main light modifier for this shot was a 20-inch beauty bowl, and the background light was a 2x3-foot softbox, powered to ⅓ stop under the main light and placed close to the background to fall off rapidly. The strip light power was ⅓ stop over the main light. My 70–200mm zoom was used at 150mm to compress the perspective and throw my chemist slightly out of focus at f/9 (images 18.6 [diagram] and 18.7).

One of the older and smaller live theaters in Minneapolis, the Southern, features a proscenium arch with intricately carved and formed plaster details that must have been spectacular when new. Well, the years have not been kind to the property, and much of the detail has been chipped away or scraped off, but the wall and arch are still intriguing, especially as a photographic background. Frankly, if I had a wall like this in my studio, I'd insure it with Lloyd's of London.

One of my professional dancer friends, Denise Armstead, rented the theater as a background for a video she was producing for her company,

Image 18.6 (top). Image 18.7 (bottom).

DADance, and had promised me some time to shoot. She and her dance partner, Gerry Girouard, had created and choreographed a tango that was outstanding as a motion piece but which begged to be shot as stills.

I'd brought quite a bit of gear to the shoot because I'd not previously seen the dance and had no idea what I would need to set up the shot. After watching the performance, I felt strip lights would create a sense of fluid drama quite nicely.

I set one strip light at each end of the wall on the left side of the arch. Each strobe was powered equally, and I made a mental note (looking at features on the wall) where the two strobes metered to the same stop. The lights were set to feather across the wall's details but were mostly aimed at the dancers, who had about five feet to move between the points of perfect exposure. As they moved from one side to the other, the two narrow softboxes took turns being main light or fill, allowing the dancers more freedom of movement than they'd have had if they'd been lit for only one place on the floor (images 18.8–18.10).

So, if you're looking for a new twist on an old standard, you might want to investigate a strip light softbox. Most manufacturers do not offer a box as narrow as Profoto's, so make sure your brand of strobe gear makes a speed ring that works with the narrow rod placement that the brand of softbox you buy will require. If you like what the softbox does as much as I do, buy another so you'll have a matched set—then go play with your toys.

Image 18.8 (left). *Image 18.9* (center). *Image 18.10* (right).

Professional bodybuilders spend long hours, painstakingly (literally!) sculpting their bodies in search of the visual perfection the sport demands, accentuating muscles that those of us who may run around the block or hop on an Airdyne a few times a week have never seen or even dreamed about.

Say what you will about the sport of bodybuilding, but you can't argue about the dedication required to become a champion. In many ways, it's the same dedication we, as professional photographers, must have to our craft if we are to rise to the top; live it, love it, eat, breathe, and sleep it, then practice, practice, practice.

My job was simple: to show my subject's physique in the best light possible. No surprise there, but I wanted to avoid some of the lighting clichés I'd seen in photos that appear on bodybuilding web sites and in magazines, most of which are very contrasty, one- or two-light setups with parabolic reflectors. The shadows are deep and sharp in order to simulate typical performance stage light and show the definition of the subject's musculature. I wanted my images to be more artsy than that, and I definitely wanted to avoid the cheesy look of a basic promo shot. You may find this technique will work for some of your subjects as well.

I wanted my images to be more artsy than that, and I wanted to avoid the cheesy look of a basic promo shot.

What made the job so technically interesting was the necessity to ignore many of the conventional "rules" I've been teaching and writing about for so long. Of course, as I am fond of saying, there are no rules to good photography, only guidelines, and those guidelines can't be successfully ignored until they're thoroughly understood.

I've always maintained that the best position for the main light, in a portrait situation, is 18 to 24 inches above the subject. For the first shot, I wanted to use a basic, one-light setup that would dramatically illustrate Keith's physique in a way that was traditional yet different enough to be noticeable. I aimed my single light into a 48-inch umbrella to get a large, soft, but somewhat contrasty light that would illuminate the subject and evenly light the background too. Unlike a traditional portrait, I wanted broad light that would show some falloff and dramatically shadow what-

ever was under it, which meant raising the light to about three feet above my subject's head. The light was set about 30 degrees relative to the lens axis (about what you would typically use for loop light) and was brought close so the light would fall down at a much steeper angle, nicely contouring the skin it fell on while shadowing the unlit side and keeping detail (image 19.1).

Image 19.1 (top). Image 19.2 (bottom).

I kept my subject about 4 feet from the background, but the light was so high that shadows from the subject were not a problem (and would not have been, even if I'd shown as much as ¾ of him). Remember the height factor of the main light when you try this yourself (image 19.2, diagram).

Another aim of my lighting for this job was to create scenarios that would work no matter where Keith moved (as long as he stayed within the metered limits). Planning ahead by setting the light, metering it from its static position so that I had a mental reference as to what would happen when he moved to any position, and giving him physical limits to move

Image 19.3 (top). **Image 19.4** (bottom).

within, allowed me to let Keith move and shoot when I liked what I saw. Minimal technical stress on me equals less shoot stress on my client (images 19.3 and 19.4).

Next up was a two strip light (plus fill light) combo. I wanted a light from each side that would define the man's shape and allow for shadow contouring while also giving me shadow detail.

I began by setting two strip light softboxes at equal distances from the center of the background, feathering the light to achieve an equal exposure over my shooting area (plus a little more, for insurance). Black bookends were placed in front of the softboxes to keep any spill off the lens. I set an additional light, with a 2x3-foot softbox, directly over my camera's lens axis, powered to 2²/₃ stops less than the main light—just enough to put some life in the shadows but not enough to screw up the two light, split-light, key.

One of the problems with split key is the multiple highlights on the subject's nose. In general portraiture, such light is not very flattering; it tends to make the nose look huge or accents the shadows along both sides of the nose.

In my opinion, such light should usually be avoided. Still, it can be terrific for a dramatic, nonportrait shot (image 19.5, diagram).

Since the fill was so minimal and not a factor in the overall composition or exposure, I decided that I would just keep a close eye on how either of the two split main lights hit my subject's face. I'd told him to move into positions but not to wait for me to shoot. The results show clearly defined lines and form accented by dramatic shadows (images 19.6–19.8).

I really liked the split key look but wanted something even more dramatic. After changing to a black seamless backdrop, I built two foamcore triangles, one on each side, using two foamcore bookends for each. I set a barebulb strobe inside each, with the stand extended to 7 feet and angled down into the bookend, then closed the fronts to get a narrow open channel. The idea was to get the triangles to produce two soft, narrow, yet clearly defined side lights (image 19.9, diagram).

The final images are mysterious and impressive (images 19.10 and 19.11).

Image 19.5

Image 19.6

Image 19.7

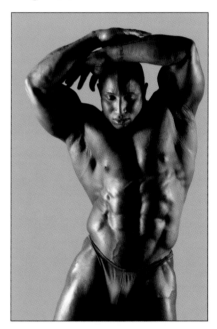

Image 19.8

Image 19.9 (left). Image 19.10 (center). Image 19.11 (right).

20. That Blasted Backlight

I've used a lot of words to stress the importance of metering your exposures so no light is powered higher than 1/3 stop over or 2/3 stop under your main light. Those words are true enough when you need images with the widest range of digitally recordable tones, but what should you do when you want a lot more zip? Here's a little trick that will do the job, yet maintain all the important colors and tones.

Hair lights are traditionally set behind and off to the side of the subject that's opposite the main light. As you've read, they're meant to act as "kickers," visually outlining the subject against the background and avoiding tonal merger. Most hair light scenarios use only one light, though you can certainly use one from each side if that fits your vision and properly accents the subject.

For this chapter, I turned my hair light (a basic parabolic fitted with a 40 degree grid) into a backlight by setting it directly behind my subject at a height just above her shoulders and aimed directly at the back of her head. My model sat about six feet from the light, but that's not a "carved in stone" distance. What's necessary is for the model's shadow to completely cover the lens. Placing the model that far ahead of the light means, perspective-wise, the parabolic reflector is effectively smaller than her head and the shadow it throws is wider (image 20.1, diagram).

Once the backlight was placed behind the model and the main light (a medium softbox) was metered, I powered the backlight up one full stop brighter than the main light and started the shoot. Because hair is thin, it lights up like a fiber optic when blasted with strong backlight, and the effect is terrific—glamorous, fun, and uptempo. A word of caution, though: if you use hot lights be especially careful not to burn the model or her hair. Strobes are much safer and easier to deal with (image 20.2, page 102).

Can this effect be intensified by increasing the backlight power? Absolutely, and with great results! More power will not make the hair any brighter. Once white reaches level 255, there is nothing brighter. Additional power only means the light will push its way through more hair, overexposing larger amounts (image 20.3, page 102).

Image 20.1

Increasing the power to 3 stops over the main light creates a halo effect around her head and face, with minimal detail in large portions of her hair. Only the most dense areas retain detail and normal color (image 20.4).

Keeping her shadow over the lens guaranteed her skin tones would not be affected by the backlight. Should the subject move and reveal the backlight, the likely result will be strong flare into the lens. You'll probably want to avoid lens flare most of the time, but you should spend some time playing with the effect. When it complements the pose, flare is a beautiful tool. Please note that your lenses may produce more flare and internal reflections than mine (image 20.5).

Aside from being alert for flare (it's hard to miss because you'll see the backlight through the lens), you'll want to watch for dust. The strong backlight will highlight any dust motes in the air, so you'll need to check your selected images for bright dust spots and retouch them.

Up to this point, I'd been using two lights, but I was curious (I'm always curious) as to how the backlight, by itself, would work with my bookend bounce technique. After I put the bookend bounce panels in place, I removed the grid so the reflector would throw the widest possible light. The difference between the exposure on the back of the subject's head and her face was over 4 stops, a real blast, but the bounce-back from the panels created beautiful wraparound light from a single source (image 20.6).

The easiest way to set this up is to place the backlight on a light stand, but this becomes problematic if you want to do any full-length shots because the stand's legs will be noticeable. The solution is to cut the back-

ground paper at the proper height and push the strobe head through it. This will cost you a few feet of seamless backdrop, but it's worth it for the effect (image 20.7, facing page).

I wanted to end this session with a full-length image, using something that would look like stage light. I once again placed the 40 degree grid on the backlight. Next, I added a hair light on each side (both parabolics fitted with 20 degree grids and metered to be $\frac{1}{3}$ stop brighter than the main light) to act as kickers. I also replaced the main softbox with a parabolic and a 10 degree grid, set over the camera and aimed at the subject's face. The multiple shadows and extra accents created a successful replication of typical stage light on a performer (images 20.8 [diagram] and 20.9).

Image 20.8 (left). Image 20.9 (right).

21. Simulated Sunlight

One of our jobs as successful photographers is to identify and exploit trends, which frequently make themselves known through commercial advertising. Like many advertising shooters, I have a love/hate relationship with art directors, those ad agency folks who dream up the ads in the first place. While I hate it when they make what I might think are dumb creative decisions during a shoot, I love them because they are paid to dream up attention-getting visuals for typically mundane subjects (and for paying me handsomely to produce the images). Art directors are often responsible for trends, because when they see a successful image from another agency, they tend to use it as a point of departure. When enough art directors do this, a trend is born through "trickle-down creative," eventually making its way through the entire industry as clients begin asking for the "look."

I've been seeing more and more national advertisements shot with simulated sunlight—beautiful images with clearly defined shadows and small, specular highlights. Is this a trend? Probably. I think we'll see this style continue for quite a while. Is it cool? Absolutely.

There are several ways to simulate sunlight, and simply going outside is not a viable option because you have no control over the situation. It's simply impractical.

HMIs were created for the motion picture and video industries. They are continuous sources like traditional hot lights and are pricey to rent (usually only from cinema supply houses) and very expensive to buy. However, they produce a very convincing "sunlight." Larger HMIs can illuminate entire city blocks.

If you use hot lights, you should use something with a focusable fresnel spot in order to keep the shadows sharp. Pay attention to the crispness of the shadow and also to the amount of fill you might need.

Far and away, the most practical lights are studio strobes. If you simply attach a small reflector, however, you may not get an authentic look, especially when lighting someone in a larger area. Light modified with a reflector will not spread out in all directions as sunlight does, nor will it create

MULTIPLE LIGHTS

You will typically need more than one light to simulate sunlight in the studio. Being that the sun is so far away from Earth, there is no diminishment of strength as it travels across the planet, much less across a room. We don't have that luxury with man-made light. It's only when your subject is literally up against the wall (or any close background) that you can get by with just one light.

Image 21.1

Image 21.2 (left). Image 21.3 (right).

a correct shadow shape. I think it's a good idea to tilt the strobe head to the 11:00 position, relative to the subject, so that the subject receives the full blast of the tube without any additional reflection from the strobe unit itself (image 21.1, facing page).

Deeper shadows can be achieved by adding a subtractive fill device, like a black bookend, to the shadow side of the image. There is a slight loss of bounced light against the background, which would not be as noticeable if the background were a darker color.

The next shot (left) would have appeared flat without the addition of a narrow strip light between the subject and the background. The strip light was angled carefully to avoid any spill onto the model or the towels. It was powered at ½ stop over the main light, as measured at the top of the frame, and allowed to fall off to give the image vertical depth, perhaps like a skylight. If I'd wished to keep it even, I'd have set the strip light vertically at camera left and feathered it evenly across the background.

The barebulb strobe, placed above and just slightly to camera right, threw beautiful, even light on the model. The crisp shadow shows plenty of detail because the bulb sprayed light in all directions and it bounced around the room. The texture of the towels looks great because the small source created a small, sharp shadow on each fabric loop (images 21.2 and 21.3, diagram).

Image 21.4 (left). Image 21.5 (right).

If you need to give the illusion of sunlight as an accent, take advantage of the barebulb's ability to produce distinct shadows and mimic the shape of a window and direct light through it. I used a pair of black bookends to create this shape. The black absorbed a lot of the extra light before it could bounce around the room and possibly affect the exposure of the main light. The window light was powered to 1 stop over the main light, a medium softbox. Even though that light was so much brighter than the main light, it brightened the dark wall, just not enough to overexpose it.

I wanted to give the image above a look of stage light, which is often perceived as a little hot, so I powered both the hair light and the background accent light to 2/3 stop brighter than the main light (images 21.4 and 21.5 diagram).

Creating a window with panes is really easy. The image shown on the facing page, shot for a magazine cover, uses an additional technique that you might find interesting.

The basic window shape was made as before, by sectioning off a piece of the studio with black bookends. After moving two light stands into position behind the bookends (so their shadows wouldn't show), I used clamps to attach a small wooden plank between them. Leaning a wider plank vertically against the crossbeam completed the illusion.

The main light, a 3x4-foot medium softbox, was aimed at the model at the same angle as the simulated sun. Another softbox was placed at camera left, very close and powered 2 stops less than the main light—just enough to open up the shadows. The modeling lamps for the main light and the window light were turned off, but the modeling lamp for the side light was left on. My shutter speed was 1.5 seconds. The strobes fired at the start of the handheld exposure, and the additional open shutter time created the warm fill and slight motion blur (image 21.6 [diagram] and 21.7).

Image 21.6 (left). Image 21.7 (right).

22. The Beam Splitter

O nce upon a time, you may have heard, there were no computers. Those of us who wished to do double or multiple exposures with complete control over the final composition had to rely on pretty archaic methods to keep track of where things were. Drawing on the camera's groundglass with a Magic Marker or grease pencil was the most popular method, but it was messy and inaccurate (and darn tough to do on a 35mm viewfinder).

Though their needs were different, Hollywood filmmakers had faced that dilemma when rendering ghosts and spirits for the big screen. The popular *Topper* series left audiences marveling and laughing at the antics of the recently deceased, and partially visible, George and Marion Kerby.

Hollywood technicians, with the help of a staggering amount of money, developed machines and gadgets to control double exposure and composition. Many were not really double exposures, but a way to photograph two scenes at once. These devices, called "beam splitters," were based on the simple premise that splitting the beam of light along the lens axis would allow a second axis to be introduced, producing a controllable double exposure. In its simplest form, a sheet of glass mounted at a 45 degree angle in front of the camera could allow the capture of whatever was in front of the camera as well as what was reflected in the glass. *Topper's* ghosts were never in the scene with Mr. Topper but were photographed on a separate set off to the side. The actors' reflections in that glass were recorded, creating the illusion that everything happened in front of the camera.

Setting up a split-beam photograph is pretty easy. I had a 20x24-inch sheet of clear acrylic plastic left over from a broken frame. I clamped it to an Avenger accessory arm and hung it a couple of feet in front of the camera. I placed a black bookend behind and to the right of the camera, matching the angle to get a reflection and draped some curtain material over it. I knew that the light fabric would wash out the skin tones of the model, so I left a depression in the middle of the fabric, skimming light over it from the side using a standard parabolic reflector (image 22.1, diagram).

Image 22.1

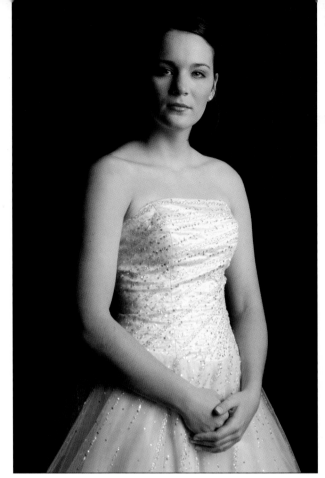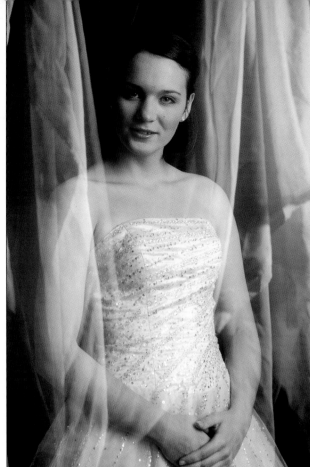

Image 22.2 (left). Image 22.3 (right).

My model was also positioned in front of a dark background and lit very simply by a 2x3-foot softbox (image 22.2).

One important note is that neither glass nor acrylic will reflect 100 percent of the light that strikes it (glass reflects more light than acrylic). The exposure of the reflected scene must be increased in order to register properly. Practice will certainly help, but it might be better to shoot tethered to the computer, at least until you get the hang of it, so that you can see the results without the inconsistencies of a camera's LCD. To get a proper "double exposure," I found I had to increase the exposure on the curtain material by 2 full stops.

Once I had the exposure figured out, it was a simple matter to move the camera so her head was centered in the depression I'd left in the fabric. The lack of light in the depression left her skin tones looking almost "normal."

This is a very interesting technique. Notice how the lightness of the fabric softens the dark background and also how she seems to be both in front of and behind the fabric. One benefit of the beam-splitter trick is the lack of negative-density exposure increase in overlapping areas, like you would expect in traditional double exposures (image 22.3).

Next, I moved a vase of silk flowers into the studio and onto a high stool. I wanted a full exposure with quick falloff, so I moved what had been the fabric light around to the front of the camera, fitted it with a 20 degree grid, and aimed it at the center of the arrangement.

I also changed the modifier on the main light to a beauty bowl to get a snappier, harder shadow. I then added a hair light so the model's dark hair wouldn't merge with the dark background (image 22.4, diagram).

After a couple of quick tests using the camera's LCD, mostly to determine if the reflections were in the right places, we shot. Notice how the gridspot's light falls off along the top of the image (image 22.5).

The beam splitter trick is wonderful for more dramatic imagery, too. Profiles and ⅞ front poses look great with this technique.

You can create your own backgrounds on your studio printer or through a lab. For the shot on page 111, I first made a 13x19-inch print of late-winter icy sludge on semigloss paper, mounted it flat onto a piece

Image 22.4 (above). Image 22.5 (left).

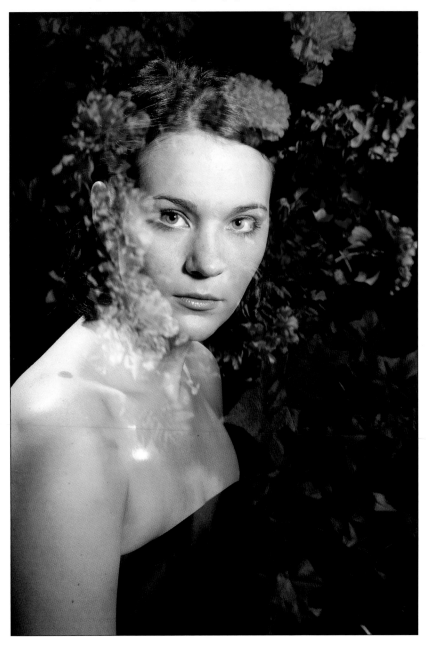

of foamcore with spray adhesive, and moved it into the reflective field until I liked it. I purposely let it go slightly out of focus, just for effect (image 22.6).

If you want the background and foreground to be equally in focus, set them at equal distances from the camera. Be sure to add the distance between the camera and the sheet of glass into the equation.

Use a large enough sheet of glass or acrylic so that you won't have to crowd it to get the composition you want. If you use too small a piece, you'll fight to keep your reflection out of the picture. Make sure the glass is clean and that no light is falling on it.

A zoom lens is extremely helpful in a situation like this because it's difficult and time consuming to move everything just because you want to get in closer.

So there you have it: another weapon in your photographic arsenal. It's a doggone cool one, too.

23. Massage the Shot, Massage the Concept

Let Your Clients Do the Work

Here's a chapter with a simple but important lesson: after you've set your lights and placed your subject in a basic position, get behind the camera. Let your subject do the rest of the work with a little direction from you.

Most subjects believe that they are incapable of terrific smiles or unguarded moments when in front of a camera. "I don't take a good picture" or "I'm just not photogenic" are phrases we've all heard many times. I take all such comments with the proverbial grain of salt, because I know in my heart I can make anyone look great. Hey, it's my job. If I don't firmly believe it, neither will my client (who will pick up on that lack of confidence without my ever saying a word).

Thanks to digital photography, we have the option of filling up memory card after memory card without spending speculative money on film and processing. This means that we can shoot much more freely without any consideration beyond the cost of our time. For me, digital allows me to massage a pose or lighting scenario to its best conclusion because I no longer have to consider the "cost per roll" against my bottom line. True, if I shot only RAW files, I could count on spending lots of extra time processing those files, but I rarely do. By controlling my exposure via a calibrated flash meter, I can get perfect JPEG images and go straight to proofs.

Image 23.1

Image 23.2

So, assuming your technical ducks are in a row, here are a few tips for getting the most out of your subjects:

1. Involve your subjects in the shoot. Don't just position them and hide behind the camera, show them images from the camera's LCD and tell them how great they look.
2. Make the subjects move. Changing the position of any body part changes the feel of the picture and involves the subject even more.

Image 23.3

Image 23.4

3. When your subjects are moving and following directions, they have less time to reflect on how stupid they might feel.
4. Watch the subject's face. If you don't like what you see, chances are your client won't, either.
5. Tell your subjects that what you do is just make-believe and that there's nothing they can do to make a fool of themselves. If anyone should play the fool it should be you, but only to get an appropriate reaction.

When my client is in place, and I've made final tweaks to the lighting, I'll begin the session with a simple pose that doesn't require any extraordinary positioning for the client. This first pose is almost always unsuccessful because the client is still relatively clueless as to how I work, and still a little nervous, so if I like the pose in principle I may go back to it later.

I begin with a simple, "Look at the camera, please. Nice." *click* "A little smile, please. Good." *click* "A little brighter smile?" *click*" And we're off. I'll direct the client through perhaps twenty minor variations of smile and position ("Chin down, just a bit." *click*). I shoot rapidly, which means the client's smiles won't have time to fade. It also means the client will focus his or her attention on my direction, giving those instructions so much attention that nervousness and apprehension will quickly fade.

Image 23.5

Image 23.6

After the first batch has been shot, I'll show the client one of the last frames. They are almost always impressed with how good they look and are ready for the next batch. By the time we're done, there are so many good images "in the can" that they frequently complain the final choice was very hard. It's music to my ears. By "massaging" the shot for nuance and subtlety instead of creating a broader range of images that won't allow the client to get comfortable, I've created a set of proofs that the client is excited to look at, consider, and order from.

For those of you who do not speak to your clients more than necessary, you must get over that hurdle. I've seen it happen dozens of times during classes. The photographer will set up a shot and spend twenty frames shooting the same pose with no direction, subtlety, or nuance. How can you expect your client to spend serious money with you if you give them so few choices, most of which are dreadfully similar?

Image 237

Image 23.8

When your subject is relaxed and encouraged by the photographer, success is so much easier. On the left, you'll find some shots—almost all of the shots, in fact—from a particular wardrobe change. By getting the client involved and relaxed, the range of expression and the number of successful images is extraordinary (images 23.1–23.8).

So far I'd shot only verticals, but a thorough shoot requires horizontals, too.

With both lights and their 6-inch parabolic reflectors aimed straight down from above, I put a light cyan gel on the light closest to the wall. I set the non-gelled light closer to the camera so only a portion of the light would fall on Ruthie's hand. The smoke machine was also moved to the wall and aimed into it, so the smoke would trail up and expand as it hit the bricks. The exposure for the hair light was measured at her hat; the other was measured at her hand. Both were powered equally. Any light hitting her face would be reflected off the smoke particles.

As the mother asked the daughter, "Where are those looks coming from?" Ruthie gave me a terrific performance. There's no doubt in my mind, nor in the mind of anyone who's seen this image, that if this were a real situation, I'd be in serious trouble. It's my favorite shot of the entire set and was worth every minute massaging the concept to make it better. By the way, no young woman was psychologically harmed by the making of these pictures. I'm not too sure about the mother (image 23.15).

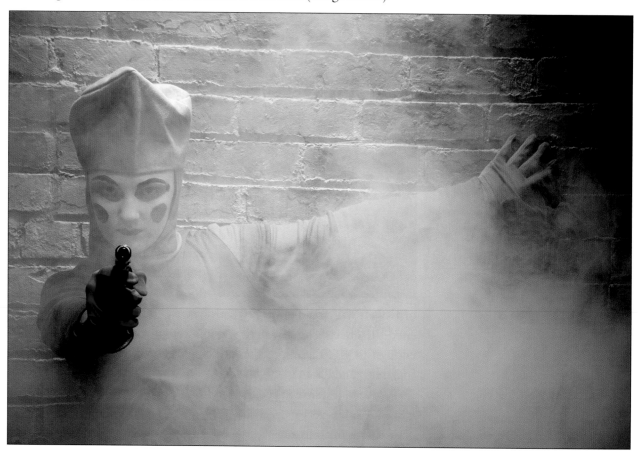

Image 23.15

24. Cut Your Background Light in Half

*Just as you should vary the look of your main light and hair lights using softboxes, grids, or other modifiers, you should seek to manipulate and finesse the background light. Many photographers settle into a lighting routine, especially with their background light. They feel that it's only needed to add dimension to the image, so why spend time fiddling with it?

Think of each light modifier as a "personality." Strong or weak, hard or soft, each modifier is a tool to help you shape your subject into what you see in your mind's eye.

I've written many times about how valuable white foamcore panels are as gobos or reflectors. Here's a simple technique to create a background light modifier from a sheet of foamcore that will baffle both clients and peers. It has got a low price going for it, too, which is nice (thanks, Carl).

I began by setting my main light, a large softbox in this case, about four feet from my subject. I was working in close quarters for this shot and didn't have the luxury of a wide-open space. Also, I wanted a soft, wrap-around light that would fall off quickly as it crossed the planes of my model's face and body.

Many photographers settle into a lighting routine, especially with their background light.

The main light itself was less than 6 feet from the background. Because of that short distance, it would light the background more brightly than I wished. To cut that light, I moved a black foamcore bookend to block about half the main light's output from striking the background wall.

Here's the trick: I balanced a 4x8-foot sheet of foamcore against an Avenger accessory arm directly behind where my model would be standing. The sheet was butted up perpendicular to the wall and as close to it as possible.

To light the background, I used a beauty bowl with a 25 degree grid (most any reflector and grid will do if the light it throws suits your vision). I aimed the light, from a high angle, directly at the point where the foamcore met the wall. The foamcore kept the background light from spreading across the back of the set (images 24.1 and 24.2, page 118).

I knew that the top of the 4x8-foot sheet of foamcore would be seen behind the model, so I planned in advance to crop slightly into the top of the

image, to hide the gobo. It's important to pay attention to how your model is moving because the gobo needs to be held at the very top of the subject. If it isn't, you may be forced to crop more deeply than you'd like (images 24.3 and 24.4).

I used a 4x8-foot panel. I keep several around in case I need another bookend. Foamcore is also available in 4- and 5-foot lengths (with a 4-foot depth), lengths that are easier to find in many markets and work just as well—even better, actually, if you wish to include airspace above the model's head. They are easy to rig, too. Just clamp the sheet to a light stand, as high as possible behind the model. Another clamp placed lower on the stand will help keep the sheet vertical. Use the model's body to block the stand and gobo from view.

The thinnest part of a model's body is the neck, and this can present a visual problem if you want a tilted head. If you have room, place the model several feet farther in front of the gobo. Such positioning makes the model much wider, visually, than the gobo. Your model is now able to make more exaggerated movements without giving away the trick.

Image 24.1 (left). Image 24.2 (right).

Image 24.3 (left). Image 24.4 (right).